THE

HOUSTORIAN

CALENDAR

Today in Houston History

JAMES GLASSMAN

THE
History
PRESS

Published by The History Press
Charleston, SC
www.historypress.com

Front cover, bottom left: Astros Rally. *Copyright Marco Torres, used with permission*; *right, third from top*: Rendez-Vous Houston. *Copyright Terry Munder, used with permission.*

First published 2019

Manufactured in the United States

ISBN 9781467139878

Library of Congress Control Number: 2018960980

Notice: The information in this book is true and complete to the best of our knowledge. It is offered without guarantee on the part of the author or The History Press. The author and The History Press disclaim all liability in connection with the use of this book.

For EBG and SMG

Who we are cannot be separated from where we're from.

—*Malcolm Gladwell,* Outliers: The Story of Success

CONTENTS

ACKNOWLEDGEMENTS

H oustorian has been a fun project, and it is my privilege to share it with you. Thanks to social media, I've been able to build this group of Houston history fans way beyond my expectations. I am indebted to all who have helped and encouraged along the way. Special thanks to Tracey Robertson and Christina Urquhart Wilkerson, who were very early supporters of Houstorian. A big thank-you to my sports editor and friend Andrew Curry. I appreciate direct or indirect support from Stephen Fox, Rod Canion, John Nova Lomax, Marco Torres, Kam Franklin, Nick Zamora, Pete Gershon, Ryan Soroka, Mike Acosta, Harrod Blank, Terry Munder, Missy Wibbelsman, Jennifer Curry, Cory and Nick van der Does, Donna Scott, Erica Gunderson, Peter Glassman and Hilary Glassman.

INTRODUCTION

I founded the history advocacy group Houstorian in 2006 as a response to the perceived public indifference to preserving Houston history, especially among younger Houstonians and newly arrived Houstonians. As a forward-looking community, we love new, but we tend to forget our past. Put another way, Houston suffers from a collective amnesia. Houstorian's mission is nothing short of changing the way Houstonians look at their own city and curing that amnesia. I want Houstorian to deepen and enrich both locals' and visitors' understanding of this history-rich community. Houstorian is active, loud and always looking for new ways to put Houston's history in everyone's heads and hearts. History lurks around every corner!

The Houstorian Calendar was inspired by my Twitter feed, where I post one or more historic events that happened on any given day. I've limited myself to one event per day on these pages.

Please enjoy.

JANUARY

JANUARY 1, 2004

Rail Returned

On this day in 2004, MetroRail opened to the public, marking the first time since Houston's last streetcar ran in 1940 that multiple generations of car-loving Houstonians had the chance to use light rail. The 7.5-mile Main Street Line (later renamed the Red Line), a $324 million light rail system, began its inaugural trip with Mayor Lee Brown, one of its strongest supporters, at the controls. Metro offered free rides all day and the following weekend at all sixteen stations connecting Downtown, Midtown, the Museum District, the Texas Medical Center and Reliant Stadium. The line, which opened one month before the Super Bowl returned to Houston, eventually carried forty-

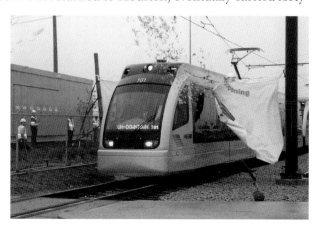

MetroRail grand opening. *Courtesy of Metropolitan Transit Authority.*

eight thousand passengers daily, making it one of the nation's most traveled routes. In 2013, it was expanded to 13 miles, offering rail service north of Downtown, to the Northline Transit Center. Today, MetroRail is three lines and covers over 23 miles.

JANUARY 2, 1924

West University Place Was Incorporated

Although the residential community saw its first "country homes" in 1920, West University Place incorporated on this day in 1924, allowing itself to provide utilities and civic services—at the time, the City of Houston had no plans to annex the community that was so far from its city limits. Even when Houston eventually proposed annexation, the municipality founded west of Kirby chose to remain independent and has been so ever since.

JANUARY 3, 1962

Astrodome Groundbreaking

Following Houston's awarding of a Major League Baseball expansion team, owners and civic leaders, including Judge Roy Hofheinz and Bob Smith, staged a ceremonial groundbreaking that included Colt .45 handguns (firing blanks), in lieu of traditional shovels, on this day in 1962. For the first three

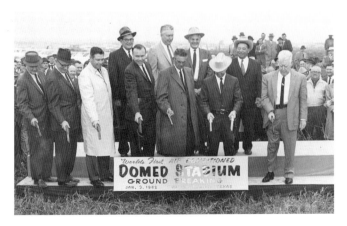

Astrodome groundbreaking. *Photo by Darling Photography. George Kirksey Papers. Courtesy of Special Collections, University of Houston Libraries.*

seasons, the team was known as the Colt .45s, but Colt Manufacturing Company objected to the use of its brand name, and the team was updated with the more Space Race–era appropriate Astros in 1965. Formally known as the Harris County Domed Stadium, the Astrodome was the world's first indoor sports arena and would be home to the Houston Astros, the Houston Oilers and the Rodeo.

JANUARY 4, 1904

John de Menil Was Born

Local businessman and arts patron Jean Menu du Menil was born in Paris, France, on this day in 1904. John de Menil married Dominique Schlumberger, whose family founded the oil services company Schlumberger Limited, in 1931 and later had five children with her. At the outset of World War II, they moved to Houston (where Schlumberger had its North American headquarters) and later commissioned architect Philip Johnson to design their International-style home in River Oaks. The de Menils were major donors to a young University of St. Thomas and founded the Art Department there. They commissioned the nondenominational Rothko Chapel, which opened in 1971. The de Menils supported human and civil rights causes, including the De Luxe Show in the Fifth Ward, and dedicated the Rothko Chapel's *Broken Obelisk* to Martin Luther King Jr. John de Menil died in 1973.

JANUARY 5, 1972

Space Shuttle Program Began

As early as 1969, looking past the Apollo missions to the Moon, NASA sought to build a presence in low Earth orbit with a reusable manned space vehicle. On this day in 1972, President Nixon announced the creation of the Space Shuttle program, with launches commencing in 1981. With large rear cargo bays, space shuttles delivered and retrieved satellites, supplied and repaired the Hubble Space Telescope and helped build the International Space Station. Houston retained its earned Apollo-era nickname, "Space City," throughout the shuttle's lifetime. Once the Space Station was completed,

the Shuttle Program lost its usefulness, and it ended in 2011. Houston was baffled and angered when, for some reason, NASA declined to give Johnson Space Center a retired shuttle.

JANUARY 6, 1980

The Renfro Play/Oilers Homecoming

Today in 1980, during the Oilers-Steelers AFC Championship at Pittsburgh, Houston Oiler wide receiver Mike Renfro made a game-tying touchdown catch, but the referee claimed he didn't have both feet in-bounds—therefore, no touchdown. The Oilers never recovered, and the Steelers went on to the Super Bowl. At that point, instant replay wasn't used by the refs, but everyone agreed that they blew the call on this "no-catch catch." Years of bitterness toward Pittsburgh festered from that painful loss. Later that day, seventy-five thousand football fans met the Houston Oilers for an emotional homecoming in the Astrodome after their second loss in the AFC Championship. Heightening the drama, the team came straight from the airport, with the buses parking on the Dome floor. Head coach Bum Phillips famously claimed, "Last year we knocked on the door. This year we beat on it. Next year we're going to kick the son of a bitch in."

JANUARY 7, 1926

Sam Houston Statue

Dedicated a year earlier in the Sunken Garden (present-day location of the Mecom Fountain), the Sam Houston Statue was relocated to its current home on this day in 1926. The new location, south of the intersection of Main and Montrose Boulevard, provided a dramatic entrance to Hermann Park.

JANUARY 8, 2012

Prudential Building Was Demolished

The eighteen-story Prudential Building, Houston's first corporate high-rise outside of Downtown, was built in 1952 for the Prudential Insurance Company in the then-small Texas Medical Center. Designed by architect Kenneth Franzheim, the Mod tower was bought by M.D. Anderson Cancer Center in 1975 and renamed Houston Main Building. Despite preservationists' pleas, M.D. Anderson demolished it to make way for the Ambulatory Care Center campus on this day in 2012.

JANUARY 9, 1858

Anson Jones Committed Suicide

In years following Texas's annexation by the United States, the last president of the Republic of Texas, Anson Jones, never held another political office, contributing to years of depression and ultimately leading him to commit suicide in the Capitol Hotel (current site of the Rice Hotel) on this day in 1858. He is buried in Glenwood Cemetery.

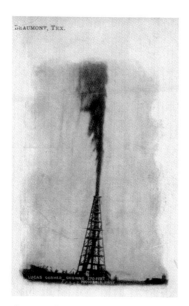

Courtesy of Port Houston.

JANUARY 10, 1901

Spindletop

Today in 1901, the first major oil well came in at Spindletop, in Harris County, south of Beaumont, marking the birth of the oil industry in Texas. The original Texas boomtown, this Beaumont home to the salt dome produced 100,000 barrels per day and made Texas the major player in the modern petroleum industry. Spindletop produced or enlarged companies such as Gulf Oil, Texaco and Humble, and storage facilities, refineries and oil field equipment companies grew quickly in nearby communities to take

advantage of the prosperous oilfield. Houston would not be the Energy Capital of the World without the huge strike at Spindletop.

JANUARY 11, 2017

City Council Approved Renaming Dowling Street

In 1892, the City of Houston renamed the street East Broadway for the colorful Irish immigrant and Confederate soldier Dick Dowling. Years earlier, in segregated Houston, the African American community had bought the land bordering the street for their own place for celebration and recreation and named it Emancipation Park. In 2016, Houston, hoping to include a greater section of the community that had been historically excluded from the naming of schools, streets and institutions, began a discussion on removing hateful Confederate figures from those places, culminating in the City of Houston Planning Commission passing a resolution to have Dowling Street renamed. On this day in 2017, City Council approved renaming it Emancipation Avenue.

JANUARY 12, 2004

Roger Clemens Un-Retired

After weeks of speculation, Roger Clemens accepted an offer from the Houston Astros to come out of retirement for one year to the tune of $5 million in 2004. Clemens graduated from Spring Woods High School in 1981 and pitched for San Jacinto College North and University of Texas. In his twenty-four seasons as a Major League Baseball pitcher, Clemens was an eleven-time All-Star and seven-time Cy Young Award winner. The Rocket negotiated a second season with the Astros and, in 2005, helped them get to their first World Series.

JANUARY 13, 1974

Super Bowl VIII

Houston opened its doors to NFL Super Bowl VIII, which saw the Miami Dolphins triumph over the Minnesota Vikings, in their second consecutive championship appearance, today in 1974. Even though the Astrodome had been hosting football games for years, Rice Stadium was able to squeeze in more fans—benches over seats. Houston would host the Super Bowl two more times. Legendary Gonzo reporter famously covered the game and the debaucherous days surrounding it in the *Rolling Stone* article "Fear and Loathing at the Super Bowl."

JANUARY 14, 1924

Howard Hughes Sr. Died

By the time Howard Hughes Sr. died, he was one of the richest men in the world. He held the patent for a revolutionary two-cone, rotary drill bit that could bust through rock and helped the boom at nearby Spindletop. His Hughes Tool Company grew its fortune through licensing the drill bit around the world. Following his father's death, only child Howard Hughes Jr. would later successfully petition the court to declare him an adult at nineteen, thus allowing him to gain control of the entire Hughes estate. Howard Hughes Sr. is buried in Glenwood Cemetery.

JANUARY 15, 1841

Houston and Austin Turnpike Company

Seeing the need for improved connection between the former capital and current capital, the Republic of Texas legislature chartered the Houston and Austin Turnpike Company on this day in 1841 to improve the existing roads for horse-drawn stages. Tolls at forty-mile minimum distances were allowed.

JANUARY 16, 1978

First Women Astronauts
On this day in 1978, NASA selected the first six women to be astronauts: Anna L. Fischer, Shannon W. Lucid, Judith Resnik, Sally K. Ride (the first American woman in space), M. Rhea Seddon and Kathryn Sullivan. NASA trained them, along with the first African American and Asian American astronauts, as mission specialists for the yet-to-launch space shuttle program. In present day, 24 percent of NASA's active astronaut corps is made up of African American, Asian, Pacific Islander, Hispanic and multi-racial astronauts.

JANUARY 17, 1870

The Gregory Institute for Colored Children Dedicated
On this day in 1870, the Gregory Institute for Colored Children was dedicated on Jefferson Avenue, between Smith Street and Louisiana Street. Edgar Gregory, a Union army officer and an agent for the Freedmen's Bureau for Texas, donated the site. This elementary school and de facto community center became a part of the Houston public school system in 1876 and was relocated twice but remained a cultural landmark for Freedmen's Town, the settlement of freed slaves west of current Downtown. Following its purchase by the City of Houston in 2000, the landmark was revived as part of the Special Collections Division of the Houston Public Library and relaunched as the African American Library at the Gregory School.

JANUARY 18, 1976

New Downtown Library
Today in 1976, the new Central Branch of Houston Public Library had its opening ceremony. The striking and spare structure, designed by architect Eugene Aubrey, stood in contrast to the previous Central Branch, the ornamented 1926 Julia Ideson Building, where generations of Houstonians had visited. The new building was connected to the former by tunnel and included a parking garage underneath. The Ideson Building would house special collections, exhibits and special events.

JANUARY 19, 1839

Capital Relocated

Today in 1839, President Lamar got his wish to move the Republic of Texas capital from Houston to what is now Austin. Legislators had been grumbling about Houston's weather from day one. Sam Houston would never forgive his political rival Lamar. (This would be the first in a long line of things taken by Austin.)

In 1842, fearing attacks from Native Americans, President Sam Houston ordered the republic's capital to be moved back to the city of Houston. Austinites suspected the president was using this as a bid to restore the capital to his namesake town and attempted to defend the relocation of documents. On January 1, 1843, the document defenders successfully prevented removal by firing a cannon at the rangers and avoided bloodshed in the so-called Texas Archive War.

JANUARY 20, 1968

The Game of the Century

Widely considered to be the game that changed college basketball forever, this first non-tournament game to be televised nationally featured the two best teams in the NCAA. In a game played in the Astrodome before the largest crowd ever to watch a college basketball game, the UCLA Bruins, with future legend Lew Alcindor (later Kareem Abdul-Jabbar), were pitted against the hometown University of Houston Cougars. Houston's "Big E" Elvin Hayes scored 39 points, living up to the hype. The Coogs won, 71–69, in this epic matchup, where the world saw that big things happen in Houston.

JANUARY 21, 1978

Houston's First MLK Day Parade

Houston's Black Heritage Society hosted the first parade honoring slain civil rights leader Dr. Martin Luther King Jr. Serving as grand marshal on that chilly day was the icon's father, Martin Luther King Sr. Since then, Houston has seen some years with competing parades and the establishment of a federal holiday honoring MLK.

JANUARY 22, 1837

Laura Arrived in Houston

On August 30, 1836, just months after Texas won its independence from Mexico, New York land speculators Augustus Allen and John Kirby Allen placed an advertisement in the local *Telegraph and Texas Register* bragging of their new "Town of Houston." Their description of the area was highly exaggerated and filled with downright lies. The biggest boast was that Houston was "situated at the head of navigation," where Buffalo Bayou and White Oak Bayou meet, and "at a point on the river which must ever command the trade of the largest and richest portion of Texas."

A few months after their colorful ad, the Allen brothers hired a captain to see if a commercial ship could, in fact, make it all the way from the Gulf of Mexico, through Galveston Bay and up to Buffalo Bayou. On this day in 1837, the packet steamer *Laura* arrived at Allen's Landing, the foot of Main Street, proving that Houston could be a port city. Local commercial enterprise was limited to regional activity until the years following the Civil War. When the new railroad network connected Houston to the nation, lumber and cotton could be shipped efficiently from the wharves along the banks of Buffalo Bayou. Dredging and widening the channel kept Houston competitive with Galveston. In the early twentieth century, civic leaders would form the Houston Ship Channel and make sure Houston received federal funds to build it. By 1914, the Ship Channel had been dredged to a depth of twenty-five feet, and today, it is a thriving fifty-two-mile, forty-five-foot-deep port connecting Houston to the world.

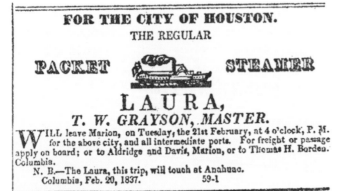

Laura notice. *From the* Telegraph and Texas Register.

JANUARY 23, 1929

Airmail Arrived from New Orleans

On this day in 1929, Contract Air Mail Route No. 29 was inaugurated by St. Tammany Gulf Coast Airways, from New Orleans to Houston, and on to other Texas towns. The rate for parcels was one dollar per pound. In 1925, Congress passed the Air Mail Act, which authorized the postmaster general to contract for domestic airmail service with commercial air carriers and to set airmail rates. The commercial aviation industry developed from these government contracts with private air service companies. Contract Air Mail routes were also known as CAMs.

JANUARY 24, 1848

Sam Houston Sworn in as U.S. Senator

Today in 1848, the man who led the Texan Army, won the Battle of San Jacinto and led the young Republic of Texas as president would represent Texas in the U.S. Senate. Two years after joining the Union, Texas sent Sam Houston to Washington, D.C.

JANUARY 25, 1915

Independence Heights

As early as 1905, the Wright Land Company developed an area outside the Houston city limits and sold lots to African Americans. The first deeds were recorded in 1908, and the first school opened in 1911. Today in 1915, the first African American municipality in Texas, Independence Heights, was incorporated north of Houston; it was later annexed by the City of Houston in 1929.

JANUARY 26, 1839

Houston and Brazos Rail Road Company Chartered

The need for infrastructure drove speculation on railways immediately following the founding of the Republic of Texas. In fact, the legislature charted four railroad companies in those early years. Today in 1839, the legislature granted a charter for Houston co-founder Augustus Allen's Houston and Brazos Rail Road Company. However, serious railway construction would not start until the 1850s.

JANUARY 27, 1961

City Hall Desegregated

By the time city hall ended its Jim Crow segregation policies in 1961, African Americans had already fought for and won desegregation of public libraries in 1953 and city buses in 1954, much of it occurring silently. Today in 1961, city hall was quietly desegregated.

JANUARY 28, 1840

The Chamber of Commerce Was Founded

Even though the fledgling, speculative Town of Houston had only a few thousand residents, business and civic leaders craved industry and manufacturing to accompany local meager agricultural ventures. Business leaders worked with local government to promote growth, whether through port improvements or turnpike and rail construction. On this day in 1840, the Third Congress granted a charter for the Chamber of Commerce. On April 4 of the same year, the Chamber of Commerce met at John Carlos's City Exchange, where they would set standard rates for freight handling and storage. The Chamber of Commerce would evolve, fail and be reborn several times well into the twentieth century. Today's version goes by the Greater Houston Partnership and was renamed in 1989 following the merge with the Houston Chamber of Commerce, the Houston Economic Development Council and the Houston World Trade Association.

JANUARY 29, 1923

Majestic Theatre Opened

The atmospheric $1 million theater opened on 908 Rusk Avenue in Downtown, with 2,500 in attendance, including the mayor and "Mr. Houston" Jesse Jones. Houston's latest landmark featured a mix of lush European architectural styles and a ceiling with twinkling "stars" (like today's Sarofim Hall at the Hobby Center for the Performing Arts). The theater would feature live performances and motion pictures until 1971 and was demolished in 1972.

JANUARY 30, 1952

The First Salt Grass Trail Ride

Even though Houston had never been much of a cow town, after the Civil War, the region saw an increase in cattle driven along the Gulf Coast to inland salt grass country. One of the more popular salt grass routes was along what became Hempstead Road. In 1952, some enterprising Houstonians revived this tradition and invited friends, all enthusiastic about reenacting the cowboy tradition. Today, the Salt Grass Trail Ride starts in Cat Springs, Texas, timed to arrive in Houston for Go Texan Day and the beginning of RodeoHouston.

JANUARY 31, 1961

Astrodome Approved

Even though Harris County voters approved the $20 million bond in 1958 for a sports stadium, more money was needed for a far costlier domed stadium. On this day, voters approved $22 million toward a sports dome for a future expansion baseball team. Chief advocate for the domed stadium Judge Roy Hofheinz shrewdly sought the African American vote by promising that the stadium would be fully integrated.

FEBRUARY

FEBRUARY 1, 2004

Super Bowl XXXVIII

On this day, Houston hosted Super Bowl XXXVIII, its second, and thirty years after its previous one. Only two years old, Reliant Stadium (now NRG Stadium) welcomed over seventy-one thousand fans when the Carolina Panthers and the New England Patriots battled for pro football's championship. Hometown hero Beyoncé sang the national anthem, but the game is remembered mostly for its infamous halftime show, where Justin Timberlake, while assisting Janet Jackson with a song, exposed her breast for a split second. The phrase "wardrobe malfunction" was coined, and the two apologized.

FEBRUARY 2, 2013

8th Wonder Brew Debuted

Today in 2013, 8th Wonder Brewery made its first batch of beers on its commercial system in a warehouse east of Downtown. The first beers were Alternate Universe, Intellectuale and Hopston. The brewery, filled with Astrodome and Houston sports memorabilia, is a reference to the Astrodome's boastful nickname the "Eighth Wonder of the World."

FEBRUARY 3, 1922

The First Archi-Arts Ball

Can we all agree that architecture students always make the coolest costumes? On this day in 1922, Rice Institute's Architecture Department students and the Architecture Society of Rice put on the first of many Archi-Arts parties, in Autry House. The theme was Baile Espanol, which informed the designs of the student-made costumes for a select group of female guests. In later years, all were encouraged to wear theme-appropriate costumes, and other departments co-hosted. The event raised money to provide traveling fellowships for architecture students.

FEBRUARY 4, 1928

Houston Had the Largest Supply of Natural Gas

Beginning in 1926, and as an offshoot of the oil industry, natural gas companies began supplying domestic and industrial service. On this day in 1928, the new Dixie Gulf Gas Company pipeline opened, giving Houston the largest supply of natural gas in the world, when eighty-five million cubic feet of gas per day began arriving from Louisiana.

FEBRUARY 5, 2011

BBVA Compass Stadium Groundbreaking

On this day in 2011, BBVA Compass Stadium, Houston's first soccer-specific stadium, broke ground east of Downtown. The stadium was a joint partnership with the new Houston Dynamo Major League Soccer team and the City of Houston. Harris County was also a co-investor and co-owns the stadium, which is designed to host football, lacrosse, rugby and concerts. After a few years of playing at University of Houston's Robertson Stadium and two MLS Championships, the Dynamo moved into BBVA Compass in May 2012. Women's soccer team the Houston Dash hit the field in 2014.

FEBRUARY 6, 1928

Houston Airmail Service

On this day in 1928, the first local airmail was delivered from Houston to Galveston and Dallas via Contract Air Mail Route 21, on Texas Air Transport's Pitcairn Mailwing biplane. In 1926, the U.S. Post Office Department assigned Contract Air Mail routes to U.S. airlines to transport mail between cities. The initial five CAM routes would grow to thirty-four and become the foundation of the U.S. airline industry.

FEBRUARY 7, 1983

DiverseWorks Opened Its First Exhibition

DiverseWorks, the bold nonprofit contemporary arts organization dedicated to presenting original literary, performing and visual arts, presented its inaugural exhibition at the swanky Texas Commerce Tower's sixtieth-floor Sky Lobby. The artist-run group was founded a year earlier but needed a temporary space while renovating its funky Market Square digs at 214 Travis Street.

FEBRUARY 8, 1982

The *Public News* Debuted

On this day in 1982, the edgy, Montrose-centric, alternate weekly free paper the *Public News* hit the streets. While not truly underground, it was a must-read for Montrose kids or anyone looking for a freaky time. It ran until 1998 and overlapped for a few years with the more corporate alt-weekly *Houston Press*. The personal ads (the dating app of the day) were always good for a laugh.

FEBRUARY 9, 1872

Glenwood Cemetery

Recognizing the need for the growing community, local investors sought to create a cemetery west of town. On this day in 1872, Houston Cemetery

Company decided to name its burial grounds Glenwood Cemetery. The rural cemetery on Washington Avenue took advantage of the rolling landscape just north of Buffalo Bayou, with a naturalistic landscape design. Following its opening that summer, many prominent Houstonians would eventually be buried there, including Charlotte Allen, Captain James Baker, George R. Brown, Will Clayton, George Hermann, Oveta Culp Hobby, William P. Hobby, Roy Hofheinz, Howard Hughes Jr., Anson Jones, Glenn McCarthy, John Staub and William Ward Watkin.

FEBRUARY 10, 1970

ZZ Top's First Gig

Today in 1970, ZZ Top played their first show in its classic lineup at a Knights of Columbus Hall on the old U.S. 90 in Beaumont. The band included founder Billy Gibbons, Dusty Hill (already sporting a beard) and Frank Beard. Less than a year later, the Little Ol' Band from Texas dropped its first full album, a bluesy, guitar-heavy rock album with all original songs. Houstonian Billy Gibbons founded the group in 1969 just outside the haze of trendy psychedelic rock. ZZ Top would go on to sell more than twenty-five million albums and was inducted into the Rock and Roll Hall of Fame in 2004.

FEBRUARY 11, 1850

BBB&C Railway Chartered

The Allen brothers knew that rail would be the future of Houston's success. In the early years of the republic, Texas legislators, eager to grow the region through commercial activity, chartered several railway companies, but none could get trains linked to Texas's most promising waterway, Buffalo Bayou. On this day in 1850, the Buffalo Bayou, Brazos & Colorado Railway was chartered by the state legislature, but rail construction was slow going. In 1856, Brazos River cotton was connected to Buffalo Bayou, and the City of Houston got permission to tap into that rail shortly thereafter.

FEBRUARY 12, 1893

Magnolia Brewery Began Beer Production

Houston Ice and Brewing incorporated in 1852 and, on this day, began beer production under its label Magnolia Brewery. The five-story facility on the banks of Buffalo Bayou, in current Market Square, would eventually grow to four city blocks and, impossibly, span Buffalo Bayou itself. In 1913, its Southern Select beer won Grand Prix in an international competition. The powerhouse brewery, among the largest in the South, was killed by Prohibition in the 1920s.

FEBRUARY 13, 1869

Newspaper Duel

Even though the Texas legislature had decided in 1836 that killing another in a duel was the same as murder, the tradition remained in practice among southerners. Sam Houston, who knew a thing about honor (and grudges), famously declined duel challenges. Following the Civil War, the City of Houston was broke and still decades away from the boom of cotton, lumber and oil. Strapped with Radical Reconstructionist dominance of local and state government, Houstonians, especially those who were Confederates, resented the "foreign" presence. Many romanticized antebellum life and embraced the tradition of the duel. On this day in 1869, two rival newspaper editors dueled, but both missed, and a bystander was killed instead.

FEBRUARY 14, 1895

Twenty-Two Inches of Snow

If you've spent any time in Houston, then you know that the concept of distinct seasons in Space City is nuanced. Fall, winter and spring are relatively mild and tend to blend into each other, but summer stands apart with its heat and humidity—especially in late August/early September. So it's hard to mock anyone who, when the temperature dips below seventy degrees in October, breaks out the scarf and mittens. (OK, maybe it's just too cold in their office.) Houstonians count themselves lucky if they get a

few weeks where they can wear their cold-weather clothes, and "chilly" is not a common word. Imagine the surprise that came when, on this day in 1895, twenty-two of snow covered the muddy streets of Houston. The late winter snowstorm stretched from Austin to New Orleans and has never been topped in H-town.

FEBRUARY 15, 2011

The Tolerance Sculptures Dedicated

Today in 2011, Buffalo Bayou Park, the 124-acre public green space along Buffalo Bayou, Allen Parkway and Memorial Drive, dedicated seven individual, human-shaped wire sculptures by Spanish artist Jaume Plensa, celebrating Houston's diverse community. The works were installed to coincide with the opening of the new pedestrian Rosemont Bridge.

FEBRUARY 16, 1982

Compaq Was Founded

Today in 1982, Rod Canion, Jim Harris and Bill Munro, former Texas Instruments senior managers, who a month earlier met at the House of Pies in preparation for a meeting with venture capitalists, incorporated their new personal computer company, Compaq. A year later, they released the Compaq Portable, which was capable of running all the popular IBM programs and was, as their advertisements boasted, "designed to travel." Looking more like luggage, the PC featured a nine-inch monochromatic screen, displaying eighty characters across, and internal memory that topped out at 128K bytes. Even though IBM, Xerox and Osborne had previously developed so-called portable computers, it was the Compaq Portable that revolutionized the industry with its lower price and IBM compatibility. During the next twenty years, Compaq built on its eighty-acre campus south of Tomball, and in 2002, Compaq and Hewlett Packard merged, becoming the world's largest PC manufacturer.

FEBRUARY 17, 1935

Johnny Bush Was Born

Today in 1935, singer/songwriter Johnny Bush, who co-wrote the classic "Whiskey River," was born in Houston. Raised in Kashmere Gardens, Bush had a hit with the song, but his friend Willie Nelson has made it his own signature opening song for as long as anyone can remember. Bush's career was sidelined by vocal cord problems, but he eventually mustered a minor comeback.

FEBRUARY 18, 1910

First Flight in Texas

Today in 1910, French aviator Louis Paulhan made the first recorded flight in Texas. A total of 2,500 Houstonians witnessed his biplane demonstration, billed as the "Greatest Invention of the Present Era."

FEBRUARY 19, 1880

Houston Post Daily Newspaper Established

On this day in 1880, Gail Borden Johnson founded the daily newspaper the *Houston Post*. It was shuttered in 1884, only to be reestablished in the merger of the *Houston Morning Chronicle* and the *Houston Evening Journal* the next year. The daily newspaper ran until 1995, when its assets were sold to Hearst, which owned Houston's other daily, the *Houston Chronicle*.

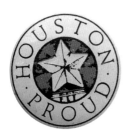

Houston Proud pin.
Author's collection.

FEBRUARY 20, 1986

Houston Proud Campaign Debuted

Today in 1986, the Houston Economic Development Council launched the Houston Proud campaign in the Downtown construction site of the future Wortham Theater. In a city still reeling from a recent oil bust, the project was meant to encourage civic

pride, promote tourism and inspire capital improvements and beautification projects through optimistic, feel-good messaging and widespread use of the slogan and logo.

FEBRUARY 21, 1912

Houston's Largest Fire

In the early twentieth century, Houston was just beginning to build with concrete, stone and steel. In Houston's industrial Fifth Ward, where many rail yards converged, most of the supporting businesses and homes were constructed with wood. On this day in 1912, a late-night fight in a neighborhood bar led to a stove overturning, starting a fire. A hard winter wind quickly carried the flames to surrounding structures, and the fire department was unable to stop the disaster. Even Buffalo Bayou wasn't able to prevent the fire from spreading south into the Second Ward. Ultimately, forty city blocks were burned to the ground, but no deaths were reported.

FEBRUARY 22, 1927

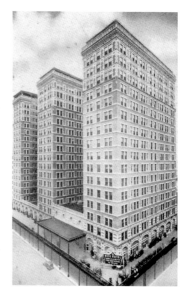

Rice Hotel Completed Its Third Wing

The 1913 Rice Hotel was built on the original site the Republic of Texas's two-story capitol building. Once the government moved to Austin, the five-story Capitol Hotel was built there. William Marsh Rice bought it in 1886, and it was renamed Rice Hotel following his death. Jesse Jones built the seventeen-story hotel that stands there today as a two-wing building but added to it. On this day in 1927, a third wing and additional floor were completed, making the Rice Hotel the largest hotel south of Chicago.

Rice Hotel. *Author's collection.*

FEBRUARY 23, 1966

The Rodeo Moved into the Astrodome

Today in 1966, the Houston Livestock Show and Rodeo began its relationship with the Astrodome and entire Astrodomain campus, growing to be the largest annual livestock exhibition in the world. It first debuted in 1931 as the Houston Fat Stock Show (renamed in 1961). In the Dome, competitions would run all day, but most Houstonians came at night to see marquee musical performances. RodeoHouston moved out of the Astrodome after 2002, following the opening of Reliant/NRG Stadium next door. In 2012, the Houston Livestock Show and Rodeo purchased forty-eight acres of empty land out of a ninety-two-acre former AstroWorld site for $42.8 million from Fort Worth investors, who themselves acquired the former amusement park land in 2010.

FEBRUARY 24, 1840

City Council Approved the First City Seal

Dr. Francis Moore Jr. was one of Houston's first misfit tinkerers. Before becoming mayor (on three separate occasions), Moore studied medicine and law, fought for Texas independence and co-owned and edited the *Telegraph and Texas Register* newspaper. Believing in the vision of the young town, Moore knew the importance of civic promotion and, on a trip to New York, commissioned Houston's first city seal. On this day in 1840, City Council approved his design. Anecdotal accounts describe the seal depicting an ox in a grassy pasture of bluebonnets. This stands in contrast to today's locomotive and plow seal, which appeared at the same time that actual trains arrived in Houston, after the Civil War. Houston business leaders yearned for Houston to be the center of all regional commercial trade in cotton, rice, sugar cane and lumber; rail lines and the Port of Houston would ensure that.

FEBRUARY 25, 1941

Mellie Esperson Building Opened

This nineteen-story annex to the Italian Renaissance–infused Niels Esperson Building opened today in 1941 on Walker Street. Businesswoman Mellie Keenan Esperson built the iconic thirty-two-story skyscraper for her late husband, Niels, in 1927. Her addition was notable for having an adjacent parking garage, and it was the first Houston high-rise to have central air conditioning.

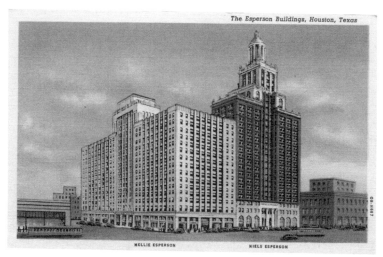

Mellie Esperson Building and Niels Esperson Building. *Author's collection.*

FEBRUARY 26, 1995

Selena's Last Concert

On this day in 1995, Mexican American pop superstar Selena played her last major concert, at the Houston Livestock Show and Rodeo. The native Texan singer, credited for popularizing Tejano music outside Texas, performed in an iconic purple jumpsuit before a sold-out audience on the Rodeo's famous rotating stage in the Astrodome (her third year in row). A month later, on the verge of a crossover to pop radio, she would be murdered by a fan who had become a disgruntled employee. In 2001, the album *Live! The Last Concert* was released, which has since kept her forever in her fans' hearts.

FEBRUARY 27, 1971

Rothko Chapel Dedication

Today in 1971, the Rothko Chapel, built by the de Menils to house fourteen Mark Rothko paintings, was dedicated. The simple and unadorned Rothko Chapel, designed by Howard Barnstone and Eugene Aubry, reflected the de Menils' growing ecumenical outlook. Facing the nondenominational chapel/gallery on a reflecting pool is Barnett Newman's *Broken Obelisk*, dedicated to Martin Luther King Jr., after the City of Houston rejected it with the Menil-requested dedication to the slain civil rights leader.

FEBRUARY 28, 1942

USS *Houston* Sank

Today in 1942, the *USS Houston* sank after being struck by the Japanese during the Battle of Sunda Strait, in the Java Sea. The site was the final resting place for as many as seven hundred U.S. sailors and marines. The loss of the cruiser, nicknamed the Galloping Ghost of the Java Coast, inspired over one thousand Houstonians to volunteer and all of Houston to donate $85 million for a replacement ship.

MARCH

MARCH 1, 1911

Union Station Opened

Today in 1911, Houston Belt and Terminal Railway opened Union Station on the northeastern edge of Downtown. Union Station served other railways and the Galveston-Houston Electric Railway, which provided hourly interurban service to the island. Generations of Houstonians passed through Union Station before it closed to passenger service in 1974. In 1996, voters agreed to a Downtown ballpark as a new home for the Astros. As historic preservation was becoming more popular, the proposed stadium would reuse the existing main hall and take design details for inspiration for the rest of what became Minute Maid Park—including that not-so-random train out above left field.

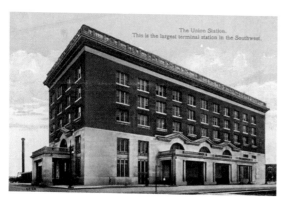

Union Station. *Author's collection.*

MARCH 2, 1793

General Sam Houston Was Born

The most important political and military leader in all of Texas's history, Sam Houston was born in Virginia on this day in 1793. Before moving to Texas in 1832, Houston lived with the Cherokee as a teen, fought against the British in 1813, resigned as governor of Tennessee and gained Cherokee citizenship. He was a shrewd yet emotional leader of the Texian Army and led them to victory at the Battle of San Jacinto, where he spared the Mexican army general Santa Anna's life in return for Mexico retreating to the Rio Grande. Houston was the first elected president of the Republic of Texas, held nuanced opinions about slavery and fought to preserve the Union. Following U.S. annexation, Sam Houston was the first governor of the state of Texas but was thrown out of office for refusing to pledge allegiance to the Confederacy. The city of Houston was named for him by the Allen brothers, although he never had a permanent residence there. He and his family lived in Huntsville, where he died in 1863. He is the only person to be governor of two U.S. states. Colorful Houston had many nicknames, including the Raven, Colloneh, Big Drunk, Old Sam Jacinto and Old Chief.

MARCH 3, 1947

Texas Southern University Was Founded

Today in 1947, the Texas legislature founded Texas Southern University. Originating as a junior college in 1927 as the Texas State University for Negroes, Third Ward–based TSU ran under the racially segregated "separate but equal" standard, providing higher education to African Americans. Famous alumni include Barbara Jordan, Yolanda Adams, Michael Strahan, Mickey Leland and Kirk Whalum.

MARCH 4, 1960

TSU Students Staged the First Civil Rights Sit-In in Texas

On this day in 1960, Texas Southern University students staged a sit-in demonstration at local chain supermarket Weingarten's. Just as soon as

the students sat down at the segregated lunch counter, the store manager closed it, and the students waited to be served until the entire store closed. Police did not interfere with the peaceful protest, and no violence was reported. Weingarten's, hoping to avoid any future sit-ins, simply removed the counter stools.

MARCH 5, 1966

Bayou Bend Opened

Today in 1966, legendary arts patron Ima Hogg's former River Oaks residence Bayou Bend opened to the public as the Museum of Fine Arts, Houston's first house museum, containing her decorative arts collection of furniture and paintings. The John Staub–designed home was completed in 1928 on a fourteen-acre site on Lazy Lane. To keep traffic from the posh River Oaks street, a pedestrian bridge was constructed over Buffalo Bayou, where, on the north bank, a visitors' center and parking lot serve the site.

MARCH 6, 1836

The Alamo Fell

Today in 1836, the Alamo, the San Antonio mission-turned-garrison where settlers had holed up, fell to the Mexican army. Months earlier, the Texian settlers forced out the Mexican government from Texas in a bid for political independence. When the Mexican army returned to retake San Antonio and restore order, a group stayed to defend their claim. Despite the arrival of supplies and soldiers, including Congressman Davy Crockett and Jim Bowie, the Alamo was seized and most were killed. When word of the slaughter reached the public, many fled for safety in the Runaway Scrape, while others were called to arms. General Sam Houston and the Texian Army would confront Santa Anna in battle outside the future town of Houston weeks later.

MARCH 7, 1927

Houston School Board Established the Junior College System

On this day in 1927, trustees of the Houston Independent School District Houston Board of Education, seeing the need for higher education for Houstonians who could neither travel nor qualify for the local Rice Institute, voted to establish a junior college. The evening classes were held at San Jacinto High School. In 1934, trustees agreed to change the school to include a four-year curriculum and rename the institution the University of Houston.

MARCH 8, 1982

Houston Food Bank Opened

Today in 1982, Houston Food Bank opened in a shopping center storefront, donated by Joan and Stanford Alexander, in North Houston as the Houston-Galveston Area Food Bank (an alliance of Houston Metropolitan Ministries, Society of St. Vincent de Paul, Interfaith Hunger Coalition, Catholic Charities and others). Within the first year, sixty-nine hunger relief agencies had joined the food bank, which allowed it to distribute one million pounds of food. By 1984, the Houston Food Bank had joined the Second Harvest Network and grew to become the largest food bank in Texas. In 1988, its new seventy-three-thousand-square-foot warehouse opened at U.S. 59 and Cavalcade, donated by Ethel and Albert Herzstein. Today, through volunteers and donations, the Houston Food Bank distributes thirty-eight million pounds of food throughout southeast Texas, feeding more than eighty thousand weekly.

MARCH 9, 2013

Downtown's Macy's Department Store Closed

Legendary Houston department store Foley's was a fixture in Downtown since 1900. In 1947, following its purchase by Federated Department Stores, it moved into the six-story flagship on Main Street. As Houston's population gradually spread away from its center, the department store dwindled in

significance as a retail hub. In 2006, Foley's became Macy's, but shoppers weren't returning. On this day in 2013, Macy's closed, and the site was demolished months later.

MARCH 10, 1974

Bruce Springsteen Played Liberty Hall

Today in 1974, Bruce Springsteen played the last of his four-night gig at Downtown's Liberty Hall, selling out seven shows in his first Texas gigs. A former church and later American Legion Post, Liberty Hall booked up-and-coming and established bands from 1971 to 1978. The rock legend later mentioned Liberty Hall in his song "This Hard Land."

MARCH 11, 1955

Kellum-Noble House Fire

The Kellum-Noble House is the oldest building constructed in Houston and includes brick walls made with mud from the banks of nearby Buffalo Bayou. Built in 1847 by Nathaniel Kellum, it later was home to the Noble family. In 1899, the City of Houston purchased the house and property for Houston's first municipal park. The two-story house with wraparound porches was the residence for the park keeper and was the site of Houston's first zoo until 1922. On this day in 1955, a fire damaged most of the former house. A group of Houstonians interested in preservation formed the Harris County Heritage Society and had the Kellum-Noble House restored. Since 1958, it has served as a museum at Sam Houston Park.

MARCH 12, 1987

Hearst Bought the *Chronicle*

Today in 1987, the Hearst Corporation bought the *Houston Chronicle*, Texas's largest daily newspaper, for $400 million. At that point, Hearst owned fourteen newspapers. Founded in 1901, the *Chronicle* was co-owned by the

Houston Endowment, a charitable trust created by Jesse Jones, who himself acquired full ownership in 1926. Hines bought the entire city block in 2015 and demolished the buildings that composed the newspaper's headquarters in 2017. The *Houston Chronicle* lives in the former *Houston Post* headquarters on the Southwest Freeway.

MARCH 13, 1955

Sharpstown Opened
Today in 1955, Frank Sharp's new subdivision Sharpstown opened in southwest Houston. Sharp, who had developed communities Royden Oaks and Oak Forest, shrewdly donated ten miles of right-of-way for the future Southwest Freeway so access to his residential and commercial development would be ensured.

MARCH 14, 1816

William Marsh Rice Was Born
On this day in 1816, Houston industrialist and founder of Rice University William Marsh Rice was born in Springfield, Massachusetts. Rice made a fortune investing in real estate, railroads, lumber and cotton. In 1900, at the age of eighty-four, he was murdered by his valet. Captain James Baker was able to save his trust, which endowed the William Marsh Rice Institute for the Advancement of Literature, Art and Science (later Rice University).

MARCH 15, 1961

Meyerland Plane Crash
Today in 1961, Texas Air National Guard pilot Gary Herod died after crashing his plane in Meyerland. After takeoff from Ellington Field, Herod experienced engine failure but guided the plane to a vacant field to avoid hitting any residences. A Hero Tree was planted in his memory in 1961, and Meyerland's Herod Elementary is named for him.

MARCH 16, 1861

Houston Expelled

Sam Houston, as commander of the Texian Army, led the fledgling nation to victory at the decisive Battle of San Jacinto and later committed his life to the welfare of Texas. He served as president of the Republic of Texas twice, represented Texas in the U.S. Senate and was finally state governor. In 1848, hoping to avert a political showdown, he spoke against allowing slavery in the West. Houston, who had fought for the rights of the Cherokee and was a slave owner, saw the Civil War on the horizon. When Texas voted to secede from the United States in February 1861, Houston opposed it as a staunch Unionist. On this date in 1861, Sam Houston, who had refused to take an oath of loyalty to the Confederate States of America, was expelled as governor of Texas. Houston took exile at his home in Huntsville and died two years later.

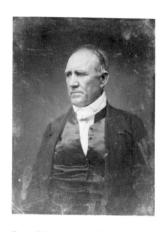

Sam Houston by Mathew Brady around 1850. *Courtesy of Library of Congress.*

MARCH 17, 1949

Shamrock Hotel Opened

Fiercely independent oilman and the so-called King of the Wildcatters Glenn McCarthy opened his ambitious Shamrock Hotel on St. Patrick's Day 1949. McCarthy shocked the public when he chose the corner of South Main Street and Bellaire Boulevard, five miles from Downtown, for the site of his flashy, eighteen-story vanity project. At its grand opening, the Shamrock hosted Houston's largest party to date, with fifty thousand people showing up to see celebrity guests, many of whom were flown in by McCarthy himself. Also known

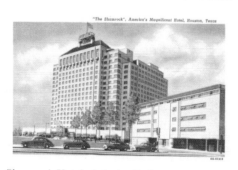

Shamrock Hotel. *Author's collection.*

for its ginormous swimming pool, able to accommodate water-skiers, it was sold to Hilton Hotels in 1955. When demolished in 1986, it was one of Houston's first and more painful landmark losses, inspiring a new generation of preservationists.

MARCH 18, 1972

Contemporary Arts Museum Opened
Today in 1972, the Contemporary Arts Museum opened the new headquarters on Montrose Boulevard at Bissonnet, across from the Museum of Fine Arts, Houston. The simple, contemporary design, with narrow vertical stainless steel panels, sets it apart from the conservative homes that surrounded it. The ground-floor gallery has a trapezoidal footprint, and the basement, with a second gallery, restrooms and a gift shop, has famously flooded more than once. Founded in 1948, the Contemporary Arts Museum sought to present and document new art and its role in modern life through exhibitions, lectures and other activities.

MARCH 19, 1974

Nixon and Rather at Jones Hall
During a press conference on a national tour, President Nixon asked CBS's White House correspondent (and former Houstonian) Dan Rather, after receiving a sustained applause, "Are you running for something?" Rather responded sarcastically, "No, sir, Mr. President. Are you?" Nixon was deep into the Watergate scandal and would resign the presidency less than five months later, thus avoiding impeachment.

MARCH 20, 1964

Houston Press Sold
Today in 1964, Scripps-Howard sold Houston's third daily newspaper to the *Houston Chronicle*. Founded in 1911, the *Houston Press* reported more

salacious stories, with sensationalist headlines. Houston would have two daily newspapers until the *Houston Post* folded in 1995.

MARCH 21, 1981

USS *Houston* Submarine Launched

Today in 1981, USS *Houston*, a U.S. Navy nuclear-powered fast-attack submarine, was launched. *Houston*, the fourth vessel to be named for the city, was commissioned on September 25, 1982, with Captain G.H. Mensch in command. Her hull number matched the Houston area code, 713. She was decommissioned on August 26, 2016.

MARCH 22, 1853

Two Steamships Raced on Buffalo Bayou

Today in 1853, two boats that connected Houston and Galveston, the *Neptune* and the *Farmer*, had their second race from Houston, down Buffalo Bayou into Trinity Bay and then to Galveston. Before trains came to Houston, steamships provided regular passenger service to the two young towns. With their first race in January from Houston to Galveston unresolved, they raced again. When the *Farmer*'s boiler exploded, the blast threw many of the seventy-two passengers into the water, and thirty-six people died, including the captain.

MARCH 23, 1908

Dominique Schlumberger de Menil Was Born

Today in 1908, arts patron, philanthropist and civil rights activist Dominique Schlumberger de Menil was born in Paris, France. In 1931, she married John de Menil and started a family. Following World War II, Schlumberger, her family's oil equipment business, moved them to Houston, where she and her husband created the Menil Foundation. Their modern European art collection, which included Abstract Expressionism, Dadaism, Minimalism

and Pop Art, became the basis for the Menil Collection, on a thirty-acre site adjacent to University of St. Thomas in Montrose. From 1964 to 1969, she led the University of St. Thomas Art History Department. She commissioned architect Renzo Piano to design her museum, which opened in 1987, and the Cy Twombly Gallery, which opened in 1995. She died in 1997.

MARCH 24, 1893

DePelchin Faith Home Chartered
On this day in 1893, just months after the death of founder Kezia Payne DePelchin, the DePelchin Faith Home was chartered. DePelchin was the matron of Bayland Orphans' Home for Boys when she began a separate home. DePelchin's new orphanage, located in a friend's home on Washington Avenue, grew to include social services for Houston's children in need.

MARCH 25, 2000

Audrey Jones Beck Building Opened
Today in 2000, the Museum of Fine Arts–Houston opened its new Audrey Jones Beck Building, a three-story, 185,000-square-foot building on Main Street directly across from the existing museum. The gray limestone structure is connected to the original museum via a tunnel, which connects to a garage on a third block. The building houses galleries for changing exhibitions and the MFAH collections of ancient art, European art, photography, prints and drawings and American art to the mid-twentieth century. The combined gallery space raised the museum's rank in square footage among art museums to sixth in the nation.

MARCH 26, 1991

Nolan Ryan Expressway Renamed
On this day in 1991, the Texas State Senate approved renaming a portion of SH 288 the Nolan Ryan Expressway, after the famed Astros and Baseball

Hall of Fame pitcher. Raised in nearby Alvin, Ryan played from 1980 to 1988 for the Houston Astros, with whom he broke the record for three thousand career strikeouts and pitched his fifth no-hitter. It's too bad that 288 was not renumbered 34 for his jersey number, which was retired by the Astros in 1996.

MARCH 27, 1942

M.D. Anderson Foundation Chose Houston

Monroe Dunaway Anderson, with Will Clayton, founded Anderson, Clayton and Company, the world's largest cotton trading company, and moved it to Houston in 1916. Upon his death, the M.D. Anderson Foundation was a major contributor to the formation of the Texas Medical Center. On this day in 1942, trustees announced that the $20 million endowed M.D. Anderson Foundation would fund a new cancer research hospital and be located in Houston. The foundation offered land and matching funds to the University of Texas, and Baylor would soon be lured from Dallas. In late September of that year, the Board of Regents formally announced that they would name the hospital the M.D. Anderson Hospital for Cancer Research of the University of Texas.

MARCH 28, 1838

Houston Hosted Its First Public Execution

On this day in 1838, convicted murderers John Quick and David Jones were executed in a public hanging, which drew a large crowd at what would later be called Hangman's Grove.

MARCH 29, 1880

President Grant Visited

On this day in 1880, former president U.S. Grant arrived by train at Houston's first Union Station. He spoke later at Pillot's Opera House and was received by a hospitable crowd at the posh Hutchins House Hotel.

MARCH 30, 1967

One Shell Plaza Groundbreaking

Developer Gerald Hines had already made his mark with a series of small office buildings along Richmond Avenue when he broke ground on his first Downtown high-rise office building, One Shell Plaza, on this day in 1967. Designed by Skidmore, Owings & Merrill, this fifty-story tower across from City Hall has been a fixture in the Houston skyline since it opened in 1971. It was Houston's tallest building until Texas Commerce Tower opened in 1981. In 2016, Shell Oil, the anchor tenant, announced that it would relocate to the Energy Corridor, leaving the landmark's future name in doubt. And Hines would continue to improve Downtown Houston's skyline with Pennzoil Place, Bank of America Center, JPMorgan Chase Tower and 609 Main.

MARCH 31, 2013

Compaq Center Sold

Today in 2010, City Council approved the sale of Compaq Center to Lakewood Church for $7.5 million. In 2001, the church began a thirty-year lease and paid the city $11.8 million in rent. Compaq Center had been mostly empty since the Houston Rockets left for their new venue Downtown. The sports and performance venue opened in Greenway Plaza as The Summit in 1976.

APRIL

APRIL 1, 1924

Bus Service Arrived

Today in 1924, local transit company Houston Electric Company, with voter approval, brought bus service to Houston. Buses were more efficient than existing jitneys (private, oversized cars) and more popular than trolleys. Houston would have three bus lines by year's end, and trolleys continued to run until 1940.

APRIL 2, 1983

Phi Slama Jama Dominated

The University of Houston basketball team, despite multiple returning starters from a team that had gone to the Final Four the previous season, was not ranked in the top ten when the 1982–83 season began. That season, they ascended all the way to #1 and stayed there entering the 1983 NCAA Tournament. Texas's Tallest Fraternity Phi Slama Jama (coined by sportswriter Thomas Bonk) was known for its fast-paced, above-the-rim style of play. Future NBA legends Hakeem Olajuwon and Clyde Drexler were joined by stars Michael Young, Larry Micheaux, Alvin Franklin and Benny Anders.

Today in 1982, Houston defeated #2-ranked Louisville in the semifinal round. People were puzzled when the brackets were released and showed

that Louisville and Houston wouldn't meet in the finals if they went far enough in the tournament. With two lesser teams playing in the other semifinal on the other side of the bracket, this was the championship game in the hearts of all Phi Slama Jama fans.

Final score: Houston 94, Louisville 81.

(NC State would beat Houston in the finals, but we won't bore you with that.)

APRIL 3, 1944

Smith v. Allwright

Lonnie E. Smith, an African American dentist from Houston, was not permitted to vote in dominant Democratic primary elections and sued county election official S.S. Allwright, challenging the state law that had authorized the party to establish its own rules (keeping black citizens from voting). The case went all the way to the U.S. Supreme Court, where, today in 1944, it ruled that primary elections must be open to voters of all races.

APRIL 4, 1969

Cooley Implanted Artificial Heart

Today in 1969, Dr. Denton Cooley became the first to implant a prototype artificial heart, co-designed by Domingo Liotta, into Haskell Karp at St. Luke's Hospital's Texas Heart Institute. The operation was intended to provide more time to seek an actual heart donor, but Karp only lived for sixty-five hours. Dr. Michael DeBakey, who had invited Cooley to collaborate with him at Methodist Hospital years earlier, was furious they had performed the surgery with an artificial heart that DeBakey had himself co-developed. The feud lasted until 2007, when Cooley finally reached out to his former mentor to seek a truce, occurring just days after DeBakey received the Congressional Gold Medal.

APRIL 5, 1986

Sesquicentennial

Houston and Texas were both founded in 1836, and for the 150th anniversary of these events, Houstonians learned a new word: *sesquicentennial*. Despite an economic recession, Houston pride was at an all-time high. Houston International Fest invited French electronic composer Jean-Michel Jarre to produce an outdoor show to celebrate Houston and Texas, along with NASA's 25th anniversary. Today in 1986, Rendez-Vous Houston: A City in Concert was staged against the backdrop of Houston's iconic (and still forming) skyline. The performance included fireworks, lasers, live music and two thousand projectors shooting against the west side of Downtown skyscrapers. Low-hanging clouds framed the light spectacular and appeared as if conjured by the crowd of over one million attendees along Buffalo Bayou. Earlier in the day, Houston's first unofficial Art Car Parade the New Music American Parade, organized by Rachel Hecker and Trish Herrera for the New Music America Festival, rolled down Montrose Boulevard.

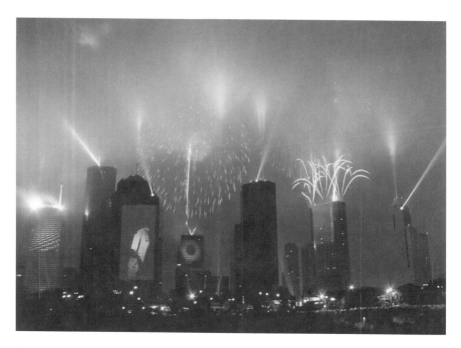

Rendez-Vous Houston. *Courtesy of Terry Munder.*

APRIL 6, 1868

Public Transportation Debuted

Today in 1868, the Houston City Railroad ran its first trolley car down McKinney Avenue with a single mule-drawn car. Even though Houston was only one square mile and mules were famously slow, a second line was added in July. Mule-powered trolley service continued off and on for many years, even coexisting with electric trolleys, until service ended in 1912.

APRIL 7, 1975

Tequila Sunrise

Today in 1975, the then-struggling Houston Astros introduced the now-iconic orange rainbow to their uniforms. Designed by advertising agency McCann Erickson, the gaudy yet groundbreaking design played off the existing Astros orange caps. The polyester, disco-era jersey was a pullover with two different scales of horizontal dark-to-light orange stripes. The color scheme also ran the length of the legs on the white pants. The flashy shades of orange contrasted perfectly with Astroturf green. In 1980, *Florida Today* sports columnist Shelby Strother coined the term "tequila sunrise," referring to the jersey's similarity to the multicolored cocktail. From 1986 and lasting until 1993, the radical rainbow was shrunk to accent stripes on the shoulders of the white or blue jerseys. Throughout the 1990s, the rainbow jersey remained in exile and would get you mocked if you dared to wear the throwbacks out in public. The fashion-forward hip-hop community, never shy about bold designs or standing out, kept the tequila sunrise in the public eye. The Astros would occasionally bring out the orange rainbow uniform for throwback games but reintroduced orange and blue in 2013, sneaking the rainbow onto the batting practice jerseys. By the time the Astros made their historic run to the world championship, the orange rainbow had been fully embraced by fans. Can you imagine the Astros without it?

APRIL 8, 1840

City Cemetery

While young Houston had private cemeteries, most notably Founders Memorial Park founded in 1836, there were no public cemeteries until this day in 1840, when the city bought five acres north of Buffalo Bayou and opened the first municipal City Cemetery. The new cemetery had four sections reflecting social and economic segregation of the era—one for whites, one for blacks, one for paupers and one for those who died by suicide or in a duel. In 1890, the site was abandoned, but it was reused in 1924 for the first Jefferson Davis Hospital (now the Elder Street Artists Lofts).

APRIL 9, 1965

Astrodome Opened

Today in 1965, Houston's signature landmark opened for an exhibition baseball game between the recently renamed Houston Astros and the New York Yankees. President Lyndon Johnson and the first lady joined Harris County judge Roy Hofheinz in a skybox for the event.

In the mid-1950s, Houston was a scrappy, ambitious, second-rate city without a professional sports team, but a few ambitious Houstonians—including Craig Cullinan, Bob Smith and George Kirksey—thought a fancy new stadium would convince Major League Baseball to expand into Texas. Dreamers like Roy Hofheinz knew that playing any sport in Houston can be a challenge, but providing a game-changer like indoor baseball would be an irresistible gimmick for a baseball franchise. Throughout the 1940s and 1950s, Houston learned that anything could, and maybe should, be air-conditioned. Both public facilities and private homes enjoyed escaping Houston's humidity in the dry, cool air. By the time Houston got its first air-conditioned shopping mall in 1961, the Houston Sports Authority had plans on paper for the world's first enclosed, air-conditioned sports venue. Harris County voters agreed, and in 1965, the Astros took to the mound under a canopy of steel and clear acrylic. The boasting began immediately—not a foreign concept for any Texan. The Eighth Wonder of the World was born.

Since its debut, the Astrodome has been an extremely versatile member of the community. Rodeo, football, soccer, basketball, tennis, boxing, bullfights, concerts, circuses, monster truck rallies, movies and even a

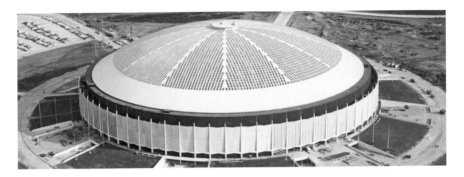

The Astrodome. *Courtesy of Special Collections, University of Houston Libraries.*

political convention held events, to varying degrees of success, in the Dome. Just about anyone who lived or visited Houston since 1965 can recall at least one cherished memory there. But the Astrodome is so much bigger than a mere monument to past sports glories.

Look at how and why we built it in the first place. Look at the bravado and ambition that produced it. Look at how the city of Houston has since become a citizen of the world. Houston built a world landmark, and then the world came to visit. Houston boasted, "Look at what we can do!" Put simply, the Astrodome is the physical manifestation of the soul of Houston.

APRIL 10, 1962

Colt .45s Debuted

The Houston Sports Authority, founded in 1958, sought to convince Major League Baseball to move an existing team or expand into Houston. By 1960, the National League had agreed to an expansion franchise, and on this day in 1962, the Houston Colt .45s debuted in a game against the Chicago Cubs. While the old-timey cowboy theme was later changed to the more appropriately modern Astros, the orange and blue colors remained. The Colts played in Colt Stadium, next to the site of the future Astrodome, for three seasons.

APRIL 11, 1837

Telegraph and Texas Register moved to Houston

The first major newspaper in Texas, the *Telegraph and Texas Register*, was founded in 1835 by Gail Borden, Thomas Borden and Joseph Baker in San Felipe. It printed the Constitution of the Republic of Texas and the original Allen brothers' advertisement for the town of Houston. Today in 1837, it moved to Houston. It ended temporarily in 1873 but was revived from 1874 to 1877.

APRIL 12, 1924

Museum of Fine Arts Opened

On this day in 1924, Museum of Fine Arts–Houston opened its doors to the public. Seven hundred guests attended, and another one thousand were turned away. Seven years to the day earlier, the site of the future museum was dedicated on land donated by George Hermann, promised months before his death in 1914. Texaco founder Joseph Cullinan helped the Houston Art League secure the land, and Rice Institute's William Ward Watkin designed the museum entrance to face Hermann Park. Wings were added in 1926, and from 1958 to 1969, the Modernist Brown Pavilion and Cullinan Hall were added to the back, following the curve of Bissonnet Street and realigning the main entrance to that side.

APRIL 13, 1970

"Houston, We've Had a Problem"

Today in 1970, during the failed Apollo 13 manned flight to the moon, astronauts Jack Swigert Jr. and later Jim Lovell broadcast to Mission Control, "Okay, Houston, we've had a problem here." The heroic story of NASA's rescue was retold in the 1995 film *Apollo 13*, where the line was rewritten as "Houston, we have a problem." To this day, the quotation is reused constantly, in any context, and usually with bad variations and/or groan-worthy puns. Eye rolls are guaranteed from any Houstonian in earshot.

APRIL 14, 1940

Ripley House Opened

Today in 1940, Edith Ripley opened the Ripley Settlement House as a memorial to her husband, banker and cotton broker Daniel Ripley. At the time, it was Houston's largest community center and included an auditorium, gym and clinic, serving the booming, industrial East End. Two years earlier, the Ripley Foundation partnered with the Houston Settlement Association, founded in 1907 to provide social services in low-income neighborhoods. Today, connecting low-income families and individuals to opportunity is the cornerstone of the organization. In 2017, Neighborhood Centers was renamed BakerRipley in honor of its two founding families.

APRIL 15, 2011

Oveta Culp Hobby Stamp Issued

Today in 2011, Oveta Culp Hobby became the first Houstonian to be featured on a stamp. Even though she was married to former governor of Texas William Hobby, Oveta Culp Hobby ultimately took her own path. During World War II, she was the first commanding officer in the Women's Army Corps, which allowed women to serve in the then-restricted U.S. Army. President Eisenhower appointed her secretary of the newly created Department of Health, Education and Welfare (now the Department of Health and Human Services). Like many noteworthy Houstonians, Hobby

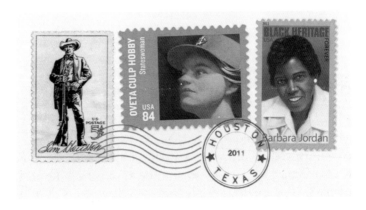

Sam Houston, Oveta Culp Hobby and Barbara Jordan stamps. *Courtesy of the U.S. Postal Service.*

was not born here; although she lived a life of privilege, she never ceased serving Houston and the nation. Later in 2011, the U.S. Postal Service would honor the late United States congresswoman Barbara Jordan with her own stamp too.

And just in case you were wondering, Sam Houston has been featured on a stamp twice—first in 1936 alongside Stephen F. Austin commemorating the Alamo and then solo in 1964. In spite of the obvious name connection, many do not consider Sam Houston a Houstonian. Actually, he never lived here full time, even when he was president of the Republic of Texas and the newly founded town of Houston was the capital. Following his first term as president, he represented San Augustine in the Texas House of Representatives. Later, he lived in Austin as president again (and as governor); in Washington, D.C., as senator; and kept a permanent residence in Huntsville.

APRIL 16, 1947

Texas City Plant Explosion

On this day in 1947, smoke appeared coming from the French ship *Grandcamp*, loaded with ammonium nitrate fertilizer, at a Ship Channel dock in Texas City. Before the flames could be extinguished, the cargo exploded, killing nearby dock workers fighting the fire. The blast was heard as far as 150 miles away, and debris from the explosion damaged adjacent refineries and a nearby residential neighborhood. Final reports listed 581 dead, 3,500 injured and damage totaling $100 million.

APRIL 17, 1953

Jack Caesar House Bombed

Riverside Terrace, a residential neighborhood along Brays Bayou and MacGregor Park, was founded in the 1930s by well-to-do Jewish families who were restricted from buying in River Oaks. When wealthy African American cattle rancher Jack Caesar bought a home in Riverside Terrace for his family, the neighbors did not take it well. On this day in 1953, a bomb was detonated on his front porch, without harming anyone. This

hastened so-called white flight from the neighborhood, and due to lapsed deed restrictions, non-residential structures moved in. Following the departure of many white families, the African American community in adjacent Third Ward blended into Riverside Terrace.

APRIL 18, 1891

President Harrison Visited

On this day in 1891, Benjamin Harrison became the first sitting U.S. president to visit Houston. With an eye on his reelection campaign, Harrison toured the South on a speaking tour meant to measure the popularity of his Republican policies. It was the first nationwide trip made by a U.S. president.

APRIL 19, 1836

General Houston's Letter

Today in 1836, two days before he would defeat Santa Anna and his Mexican army, General Sam Houston explained his strategy. Many were confused by Houston moving the Texian Army east, away from Santa Anna. General Houston explained in a letter:

> This morning we are in preparation to meet Sant Ana. It is the only chance of saving Texas. From time to time I have looked for re-inforcements in vain. The Convention adjourning to Harrisburgh struck panic throughout the country. Texas could have started at least 4000 men; we will only have about 700 to march with beside the Camp Guard. We go to conquer. It is wisdom growing out of necessity to meet and fight the enemy now. Every consideration enforces it. No previous occasion would justify it. The troops are in fine spirits, and now is the time for action.

APRIL 20, 1948

Battleship *Texas* Arrived at San Jacinto

Built in 1914 to be the most powerful weapon in the world, the Battleship *Texas* served in both World War I and World War II, and following its last mission, the State of Texas acquired it. On this day in 1948, the USS *Texas* arrived at the San Jacinto Memorial Site and was decommissioned the next day. Today, Battleship *Texas* is a floating museum and is both a National Historic Landmark and a National Mechanical Engineering Landmark.

APRIL 21, 1836

Battle of San Jacinto

On this day in 1836, the decisive final battle in Texas's war for independence from Mexico was fought and won on a prairie at the mouth of the San Jacinto River. General Sam Houston and the Texian Army defeated President Santa Anna and the Mexican army of over six hundred soldiers weeks after the Texians were murdered at the Alamo and Goliad, which inspired the famous rallying cry "Remember the Alamo! Remember Goliad!"

Santa Anna would eventually be captured and brought to a wounded Sam Houston on the battlefield. Ignoring the public's cries for the Mexican leader's execution, Sam Houston shrewdly allowed Santa Anna to stay alive to ensure Mexico's recognition of the new Republic of Texas and the Mexican army's retreat to the Rio Grande.

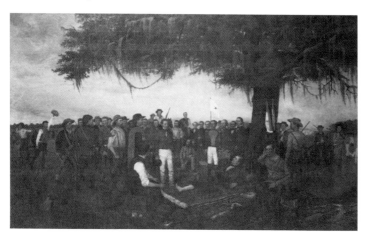

The Surrender of Santa Anna, by William Henry Huddle, 1886. *The Lyda Hill Texas Collection of Photographs in Carol M. Highsmith's America Project, Library of Congress, Prints and Photographs Division.*

APRIL 22, 1876

Ship Channel Improvements

In 1874, the shipping tycoon Commodore Charles Morgan bought the Buffalo Bayou Ship Channel Company, intending to construct a 9-foot-deep and 120-foot-wide channel from Houston to Galveston Bay and then a rail line to connect his docks with the railroads in Houston. On this day in 1876, those improvements to the Ship Channel were completed, allowing Commodore Morgan's ship to reach the turning basin at Sims and Buffalo Bayous, where freight was then sent by rail to Houston. Morgan's monopoly over channel traffic would end in 1881, when the federal government agreed to purchase Morgan's channel improvements.

APRIL 23, 1836

Founders Memorial Park Dedicated

Far outside Houston's western city limits, south of Buffalo Bayou, the city's oldest private cemetery was dedicated on this day in 1836. Also known as Campbell's Cemetery, Founders Memorial Park was intended originally for Methodists. By 1844, Hebrew Cemetery had opened on adjacent land. The cemetery, the final resting place for Houston co-founder John Kirby Allen and other prominent early Houstonians, has been maintained by the Houston Parks and Recreation Department since 1947.

APRIL 24, 1990

NASA Launched Hubble Space Telescope

Today in 1990, the Hubble space telescope became the first major optical telescope to be placed in space, free from the obstacle of earth, thus providing an unobstructed view of planets in this solar system and of distant stars and galaxies. Since the telescope's deployment in low Earth orbit about 340 miles in altitude, NASA has had five servicing missions to allow more than twenty-five years of operation.

APRIL 25, 1869

Annunciation Church Cornerstone Laid

Today in 1869, the cornerstone was laid for the Roman Catholic parish's Annunciation Catholic Church at the corner of Texas Avenue and Crawford Street. Texas architect Nicholas J. Clayton later designed extensive repairs and additions in the 1880s. Annunciation is considered Houston's oldest church building and was recorded as a Texas historic landmark in 1969.

Author's collection.

APRIL 26, 1940

Frontier Fiesta Debuted

The annual spring student-run, cowboy-themed carnival at the University of Houston, raising scholarship money, debuted on this day in 1940. Students and alumni built the temporary Fiesta City on campus for cook-offs, concerts and booths. It was halted during World War II but resumed in 1947 through 1959 and was revived in the spring of 1992 as a student and alumni event, continuing to this day.

APRIL 27, 1990

Cynthia Woods Mitchell Pavilion Opened

The Woodlands founder George Mitchell and his wife, Cynthia Woods Mitchell, dreamed of having an open-air performing arts venue for The Woodlands since its founding in 1974. On this day in 1990, the Houston Symphony performed, and on the following day, Frank Sinatra sang in concert. Today, the Pavilion presents between fifty and sixty-five events from March through December, with a wide range of musical shows.

APRIL 28, 1967

Muhammad Ali Arrested

Olympic gold medal winner and World Heavyweight Championship boxer Muhammad Ali was an outspoken critic of the Vietnam War. Following his draft into the army, he refused induction, and on this day in 1967, he was arrested in Houston. His sentencing would follow a conviction, both happening in Houston courtrooms. The U.S. Supreme Court later overturned the conviction.

APRIL 29, 1981

Li Cunxin Detained

On this day in 1981, Li Cunxin, a Chinese ballet dancer on a cultural exchange with the Houston Ballet, was freed from the local Chinese consulate, where he had gone to plead his case for remaining in the United States with his new American bride, Elizabeth Mackey. Li, with only a day left on his visa, got an extension with the help of officials of the Houston Ballet and Vice President George H.W. Bush and Barbara Bush. While his act was not technically a defection, Li's Chinese citizenship was eventually revoked. Li would become a principal dancer in the Houston Ballet, performing under artistic director Ben Stevenson until 1995. In 2003, the international incident was depicted in Li's autobiography, *Mao's Last Dancer*, and later adapted into a motion picture in 2009.

APRIL 30, 1932

First Houston Fat Stock Show Debuted

Even though Fort Worth had the largest livestock show in Texas at the time, Houston businessmen dreamed of creating a Houston version to showcase the local cattle industry. Today in 1932, the Houston Fat Stock Show and Live Exposition debuted at the Sam Houston Hall, with two thousand in attendance. When the Sam Houston Hall was replaced by the Sam Houston Coliseum in 1938, the Rodeo had grown to include the signature Downtown parade. In 1942, the Rodeo added singing cowboy Gene Autry, starting the tradition of inviting entertainers, which continues to this day. The yearly Houston event was moved to March and renamed the Houston Livestock Show and Rodeo in 1961.

MAY

MAY 1, 1969

Wes Anderson Was Born

Today in 1969, Wes Anderson, the inventive filmmaker who co-wrote and directed the movies *Rushmore* and Oscar-nominated *The Royal Tenenbaums*, *Moonrise Kingdom* and *The Grand Budapest Hotel*, was born. Anderson graduated from Houston's St. John's School, where he shot and set much of the modern classic film *Rushmore*.

MAY 2, 1956

Ideal X Arrived

At the time, standard truck trailers transported goods in thirty-five-foot-long containers. Trucking magnate Malcolm McLean saw an opportunity to save time and money by employing standardized shipping containers and improving methods for loading and unloading them onto converted tankers. On April 26, 1956, his experimental ship, dubbed *Ideal X*, departed the Port of Newark, New Jersey, where it carried fifty-eight containers and a load of fifteen thousand tons of bulk petroleum. Today in 1956, this first container ship arrived at the Port of Houston on its maiden voyage. In the present day, nearly 90 percent of global cargo is shipped by container.

MAY 3, 1968

Nation's First Heart Transplant

On this day in 1968, Houston native Dr. Denton Cooley transplanted a heart into Everett Thomas, who survived for 204 days. Months earlier, two unsuccessful transplants had inspired the brash and brilliant heart surgeon, already considered one of the best in the world, to attempt the transplant at the Texas Medical Center's St. Luke's Hospital. Over the next forty years, Cooley and his team would perform 100,000 transplants.

MAY 4, 1837

Congress Convened in Houston

The First Congress of the Republic of Texas convened in 1836 in Columbia, Texas. The following spring, it reconvened in Houston, the nation's new capital, on May 1, but did not reach a quorum to start legislating until this day in 1837. The newly elected president, Sam Houston, arrived to his namesake town only a week earlier. The Allen brothers built the Capitol Building (where the Rice Hotel sits in present day), although the structure was famously unfinished during the legislative session.

Capitol Hotel. *MSS1248-3335, Houston Public Library, HMRC.*

MAY 5, 1961

First American in Space

On this day in 1961, Freedom 7, the first piloted Mercury spacecraft, carrying astronaut Alan B. Shepard Jr., was launched from NASA's Cape Canaveral to an altitude of 115 nautical miles and a range of 302 miles, reaching a speed of 5,100 miles per hour. During his fifteen-minute flight, Shepard became the first American in space before splashing down in the Atlantic Ocean.

MAY 6, 1996

Alley Theatre Won a Tony Award

Today in 1996, the Regional Theatre Tony Award, a special noncompetitive award given annually to a regional theater company, was given to the Alley Theatre. Earlier in that season, the Alley hosted Vanessa Redgrave and Corin Redgrave's Moving Theatre Company and their productions of *Antony and Cleopatra* and *Julius Caesar*.

MAY 7, 1978

Moody Park Riot

In 1977, the body of Joe Campos Torres, a twenty-three-year-old Mexican American army veteran, was found floating in Buffalo Bayou. Campos, who was last seen in police custody, was murdered by three police officers, who were eventually charged and convicted for the crime. When their sentence was suspended, the Latino community protested, leading to riots in Northside's Moody Park on this day in 1978.

MAY 8, 1926

American General Insurance Company Is Chartered

Native Houstonian Gus Wortham established the John L. Wortham & Son Agency insurance firm with his father early in the twentieth century.

Following his father's death, Wortham founded the fire and casualty insurance business American General Insurance Company, chartered on this day in 1926. Wortham received the backing of Jesse Jones, was president of the Chamber of Commerce and was board chair of the Houston Symphony. Like Jones Hall, the Gus S. Wortham Theater was built with private money and donated to the City of Houston upon completion in 1987.

MAY 9, 1979

Orange Show Opened

Today in 1979, the Orange Show Center for Visionary Art opened to the public. Retired mailman Jeff McKissack built this folk art installation with found materials out of his home as a monument to the fruit. Following his death the next year, a group of fans and arts patrons, under the leadership of Marilyn Oshman, founded the Orange Show Foundation to assist in the purchase and restoration of the funky landmark. In 1982, the Orange Show Monument reopened and integrated the Orange Show Center for Visionary Art into Houston's cultural life. In the following years, the nonprofit organization has promoted arts education and folk art, purchased the similar funky landmark Beer Can House and hosted Houston's world-famous Art Car Parade.

MAY 10, 1999

Greater East End Management District Chartered

On this day in 1999, the Greater East End Management District was created by the Seventy-Sixth Texas Legislature as a tool for economic development and revitalization of the sixteen-square-mile residential and commercial neighborhood east of Downtown Houston. The district receives assessments from commercial property owners for reinvestment to infrastructure improvements, beautification, public safety and workforce development. The creation of the district, along with the opening of a light-rail line along Harrisburg Boulevard and the BBVA Compass Stadium, hastened an economic renaissance for the East End.

MAY 11, 1976

Worst Traffic Accident

On this day in 1976, a tanker truck from the Transport Company of Texas struck the guardrail on the ramp from Loop 610, hit an overpass support column and fell onto the Southwest Freeway below. The cargo—seven thousand gallons of pressurized industrial anhydrous ammonia—was released from the tanker truck as a poisonous gas cloud, with the fumes killing seven and hospitalizing seventy-eight. The National Transportation Safety Board determined that the cause of the accident was from the excessive speed of the vehicle, which allowed a lateral surge of liquid in the partially loaded truck to overturn. Since the accident, large cargoes of hazardous chemical are not permitted in the Loop.

MAY 12, 1925

Hermann Hospital Opened

Lumber, real estate and oil millionaire George Hermann died in 1914 without any heirs. In his will, he donated 285 acres for a park, adjacent to Rice Institute, which would become Hermann Park and the site for Hermann Hospital. On this day in 1925, his dream for a new public hospital opened and became the first institution in the future Texas Medical Center.

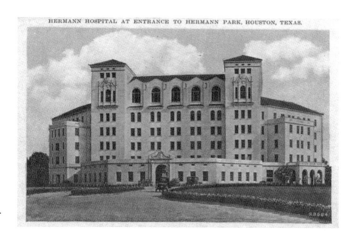

Hermann Hospital.
Author's collection.

MAY 13, 2016

The Cistern Opened

In 1926, the City of Houston built an enclosed water reservoir on the north bank of Buffalo Bayou in the former Sixth Ward. The storage facility was over 25 feet tall, with over two hundred slender concrete columns spanning the space, an eight-inch-thick concrete roof and eight-inch-thick concrete sidewalls, and it held fifteen million gallons of water. Earth was added on top to give the illusion of being underground. By the time it was decommissioned in 2007, the city had already replaced all of its early underground reservoirs, which had supported the municipal needs for fire hydrants and drinking water. In 2010, the City of Houston had commenced its demolition when the Buffalo Bayou Partnership, planning a $58 million overhaul of Buffalo Bayou Park, convinced the city to preserve the forgotten 87,500-square-foot space. An understated renovation, including installation of a six-foot-wide walkway with guardrails, was included in the park's scope. On this day in 2016, the Buffalo Bayou Park Cistern opened to the public as a public space for art installations. Landscape architect Kevin Shanley dubbed the reservoir "the Cistern" because of its resemblance to ancient Roman cisterns.

MAY 14, 1836

Treaties of Velasco Signed

The decisive Battle of San Jacinto ended hostilities between Texas and Mexico. Three weeks later, on this day in 1836, Mexican president Santa Anna signed the Treaties of Velasco, allowing him to keep his life in return for Mexico retreating to the Rio Grande. There were two separate sets, one public and one private, but they were never ratified by Mexico, which hoped to re-invade Texas. Later, these served as the public basis for President James Polk's Mexican-American War.

MAY 15, 1837

Audubon Visited Houston

Following a three-week stay in Galveston, famed naturalist John James Audubon arrived in Houston and discovered shanties, drunk Indians, a roofless capitol and President Sam Houston. Later, the Republic of Texas made Audubon an honorary Texan.

MAY 16, 2011

KUHA Began Broadcasting

In the summer of 2010, the University of Houston announced its plan to buy Rice University's beloved student-run college radio station, KTRU. On this day in 2011, KUHF's classical music programs switched over to the former KTRU's 91.7 FM under the call letters KUHA, making KUHF a full-time NPR news and talk station. (KTRU found a home on KPFT's digital channel, then back on the air at 96.1 FM.) The new station struggled, and in 2015, University of Houston System announced its intention to sell KUHA. The next summer, following the sale to KSBJ, the radio station ended over-the-air broadcasting, and classical music programming moved to online streaming and digital channels.

MAY 17, 1974

NASA Launched the First Geosynchronous Weather Satellite

On this day in 1974, NASA launched the first meteorological satellite, SMS-1, to observe the Earth's atmosphere. Following the success of the Applications Technology Satellite research satellites, NASA saw the use for placing satellites in geosynchronous orbit permanently. The new spacecraft, developed by NASA and run by the National Oceanic and Atmospheric Administration, would be employed for meteorological forecasting, research and severe storm tracking—something that all hurricane-fearing Houstonians now take for granted.

MAY 18, 1968

"Tighten Up" Was Number One

Today in 1968, "Tighten Up," the soulful early funk song by Archie Bell & the Drells, reached the top of the Billboard charts. Houston disc jockey Skipper Lee had the idea to put one of TSU Tornadoes' popular instrumental jams together with singer Archie Bell, making the seemingly spontaneous song come alive. In the intro, Bell famously name-checked Houston: "In Houston, we don't only sing, we dance just as good as we want!"

MAY 19, 1969

OTC Debuted

Today in 1969, the Offshore Technology Conference (OTC) debuted at Houston's Albert Thomas Convention Center. Responding to the growing technological needs of global ocean extraction and environmental protection industries, 12 engineering and scientific organizations founded the annual trade show, which has since become the largest oil and gas event in the world, featuring more than 2,300 exhibitors and attendees representing one hundred countries. The OTC is now Houston's largest annual convention and takes place at Reliant Park. To extend OTC's reach around the world, spinoffs OTC Brasil, the Arctic Technology Conference and OTC Asia were created.

MAY 20, 1895

Full-Time Fire Department

Houston City Council voted to create a full-time fire department, replacing the volunteer and commercial fire protection companies and bucket brigades that had been serving Houston since 1838. The new Houston Fire Department began operations on June 1, 1895, with forty-four firefighters and the seven existing volunteer fire stations taken over by the city.

MAY 21, 1986

Rockets Advanced to the NBA Finals

The 1985–86 Houston Rockets were considered the team of the future. Built around the Twin Towers of Hakeem Olajuwon and Ralph Sampson, the Rockets were thought to be too young to hang with the defending champion Los Angeles Lakers when they met in the Western Conference Finals. But not only did the Rockets hang with the Lakers, they took a three-games-to-one lead heading into the fifth game of the series. By the end of this epic matchup, Olajuwon had been ejected for fighting, and Sampson was left as the lone Tower to carry the team. With the game tied at 112, and with only one second left on the clock, Sampson took a lob pass from Rodney McCray, contorted himself to face the basket and hurled a shot that miraculously bounced in, winning the game. It was unquestionably the finest moment in Sampson's oft-maligned career with the Rockets. Unfortunately, a World Championship would elude Space City, as Houston lost in the finals to a Celtics team considered one of the best in NBA history. But the Rockets' time would eventually come. Sadly, though, that time would never be with this nucleus of players, as Sampson was hobbled by injuries and John Lucas, Mitchell Wiggins and Lew Lloyd battled drugs and league suspensions.

MAY 22, 1991

Queen Elizabeth II Visited Houston

Today in 1991, Queen Elizabeth II and her husband, Prince Philip, visited Houston. Mayor Kathy Whitmire greeted the royal couple at a City Hall reception and then joined them at Downtown's Antioch Missionary Baptist Church, where they listened to gospel music with Houston's leading black religious leaders. Her Highness reportedly clapped along and tapped her feet. Following a luncheon attended by three hundred business and community leaders, Queen Elizabeth and Prince Philip visited Mission Control at the Johnson Space Center. That evening, Governor Ann Richards joined one hundred guests for a private dinner at the Museum of Fine Arts, where the monarch granted honorary knighthood to British-born Texas Instruments co-founder Cecil H. Green. Their twelve-day visit to the United States included Austin, Dallas and San Antonio, where, yes, Queen Elizabeth remembered the Alamo.

MAY 23, 1951

Texas Children's Hospital Groundbreaking

On this day in 1951, the Texas Children's Hospital broke ground on the Abercrombie Building, its first. When the three-story, 106-bed facility opened in 1954, it became Houston's first pediatric hospital and was home to Baylor College of Medicine's primary pediatric training. Today, the hospital includes the five-story West Tower, which houses critical-care and surgical services, and the twelve-story Clinical Care Center, making it the largest freestanding pediatric hospital in the United States. In 2011, Texas Children's opened the West Campus on fifty-five acres in West Houston, and in 2012, it opened the Pavilion for Women, a fifteen-story, $575 million hospital for women's, fetal and newborn healthcare. Texas Children's opened its second community hospital, a $300 million facility in The Woodlands, in 2017.

MAY 24, 1969

Moon Landing Dress Rehearsal

On this day in 1969, Apollo 10, the first lunar mission of the full spacecraft, completed its "dress rehearsal" for moon landing and began its trans-Earth injection return to Earth. As the fourth manned flight of the command and service modules and the second manned flight of the lunar module, Apollo 10 confirmed that an actual lunar landing was possible. Apollo 11 would prove it later that year.

MAY 25, 1953

Channel 8 First Broadcast

Today in 1953, KUHT Channel 8 began broadcasting, becoming the first educational public television station in the United States. University of Houston (and Houston Independent School District until 1959) held the educational nonprofit license, and UH remains the home to the local PBS affiliate station. Prior to founding the television station, Professor John Schwarzwalder established KUHF-FM out of the Radio-Television Department. With a faculty and staff of 43 and 470 students, Schwarzwalder

developed and produced most of the programs during its first year. In 1969, the Association for Community Television (ACT), the fundraising organization for Houston's educational station, was created, which helped fund the classic public television show *Sesame Street*. In 2011, University of Houston merged television station KUHT-PBS Houston with radio stations KUHF-News 88.7 and KUHA-Classical 91.7 and its web services under the name Houston Public Media.

MAY 26, 2016

Fifty-Two Strikeouts

At the end of a three-game series, the Astros struck out fifty-two batters, setting a Major League Baseball record (the previous record was forty-seven strikeouts). The future World Series champs struck out nineteen in the first game, eighteen the next day and fifteen strikeouts on this day in 2016, sweeping the Baltimore Orioles at Minute Maid Park. The Astros also became the first MLB team since 1913 to strike out fifteen batters in three consecutive games. The Houston Astros would go on to win the World Series in the following season.

MAY 27, 1950

Washburn Tunnel Opened

On this day in 1950, the Washburn Tunnel, a two-lane underwater roadway connecting Galena Park and Pasadena under Buffalo Bayou, had its grand opening. The tunnel, still in use today, is nearly a half mile long, with a roadway width of twenty-two feet—each lane being ten feet wide. During construction, a trench for each ninety-foot-by-forty-foot section was dug. The prefabricated cement sections were lowered into place and locked into position eighty-five feet below the Ship Channel. Sections lined with concrete had water pumped out, and ventilation and lighting were installed. The tunnel's south entrance is just a few steps from the historic site of General Santa Anna's capture days after his defeat at San Jacinto miles downstream. The Washburn Tunnel was added to the National Register of Historic Places in 2008.

MAY 28, 1971

First National Chicana Conference

Today in 1971, approximately six hundred Mexican American women from twenty-four states met at the Magnolia Park YMCA for the Conferencia de Mujeres por la Raza, or National Chicana Conference. The three-day meeting, organized by local television reporter Elma Barrera and others, sought to be a response to racial and gender inequality in the Chicano and feminist movements. In seminars and workshops, attendees discussed racism, welfare, employment discrimination, gender discrimination, abortion, child care and birth control. One of their progressive resolutions asserted, "Free, legal abortions and birth control for the Chicano community, controlled by the Chicanas. As Chicanas, we have the right to control our own bodies."

MAY 29, 1999

Space Shuttle Docked at International Space Station

Today in 1999, the Space Shuttle *Discovery* became the first to dock with the International Space Station, delivering a Russian cargo crane, the SPACEHAB Oceaneering Space System Box, and an American crane. In all, thirty-four shuttle missions were flown during construction of the space station, which established a permanent human habitat in low Earth orbit for science and research. Completed in 2011, the station is 356 feet across and 290 feet long. Sixteen nations, including Brazil, Canada, Japan and Russia, and the European Space Agency support the ISS with scientific and technological resources. Following the end of the Space Shuttle program, private company Space X and American and Japanese automated transfer vehicles supply cargo to the station, and Russian Soyuz rockets transport crew. The ISS ranks as one of humankind's highest technological achievements.

MAY 30, 1942

USS *Houston* Swearing-In Ceremony

On this day in 1942, one thousand local men, also known as the Houston Volunteers, were inducted into the United States Navy following the loss of

the USS *Houston* in the Battle of Sunda Strait earlier that year. Houstonians rallied to raise funds to replace their namesake ship, with war bond subscriptions totaling $85 million. Thousands witnessed the Downtown rally and parade that included several hundred navy officers and four bands, while forty-eight bombers from nearby Ellington Field flew over. Rear Admiral William Glassford swore in the volunteers and spoke about the *Houston*'s final battle. The mayor read a message from President Franklin Roosevelt, who had had four presidential cruises on the USS *Houston*. The president wrote:

I knew that ship and loved her. Her officers and men were my friends.... Not one of us doubts that the thousand naval recruits sworn in today will carry on with the same spirit shown by the gallant men who have gone before them. Not one of us doubts that every true Texan and every true American will back up these new fighting men, with all our hearts and all our efforts.

MAY 31, 1971

Houston Community College Chartered

Houston Community College was founded in 1971, when voters in the Houston Independent School District approved a community college district to share facilities with the HISD. On this day in 1971, Houston Community College was chartered by the Texas legislature. The open-admission public institution of higher education offered a high-quality, affordable education for academic advancement, workforce training, career development and lifelong learning. In 1989, HCC separated from HISD and established its own Board of Trustees, and in 1992, it restructured into a multi-college system. Today, Houston Community College's service area is Houston Independent School District; Katy, Spring Branch and Alief Independent School Districts; Stafford Municipal District; and the Fort Bend portion of Missouri City.

JUNE

JUNE 1, 1968

AstroWorld Opened

Today in 1968, AstroWorld, the theme park designed by Judge Hofheinz, adjacent to the Astrodome, opened on the opposite side of Loop 610. A pedestrian bridge connected AstroWorld to the massive Astrodome parking lot, where countless Houston kids were dropped off for a day of riding roller coasters, seeing live shows and eating junk food. Not to be outdone by Disneyland, Hofheinz divided the park into themed areas and populated it with a menagerie of odd mascots led by the happy, redheaded gypsy Marvel McFey. In 1975, Hofheinz sold the park to the Six Flags Corporation, which ran a similar park outside Dallas. The next season, it opened AstroWorld's signature attraction, the old-school wooden roller coaster the Texas Cyclone. Southern Star Amphitheater opened next door in 1980, and Houston's first major water park, WaterWorld, opened on the other side in 1983. When Six Flags was bought by Time Warner in the 1990s, Looney Tunes characters and DC Comics

Marvel McFey. *Author's collection.*

superheroes invaded AstroWorld. Lagging ticket sales led to the park closing in 2005 and its demolition the following year. The land is vacant to date, and Houston remains without a theme park.

JUNE 2, 2016

Dave Ward Set News Anchor Record

Today in 2016, *The Guinness Book of World Records* recognized Channel 13's Dave Ward as the longest-running local TV news anchor, at the same station and in the same market. Ward's tenure at Channel 13 began in 1966 as a reporter and photographer, and two years later, he made it to the anchor desk. He set the record with forty-nine years and 218 days on the job but continued until he retired on May 2, 2017, with more than fifty years at the ABC affiliate. Sadly, he only held the record for a few months before he was passed by Rochester, New York's Don Alhart.

JUNE 3, 1976

Ensemble Theatre Founded

Today in 1976, George Hawkins founded the Black Ensemble Company to provide diverse roles for African American actors, writers and artists. Beginning as a touring company, the Ensemble grew to become a Houston cultural landmark and is the oldest professional African American theater in the Southwest and the nation's largest African American theater that owns and operates its own facility. Its first home was in a storefront at 1010 Tuam Street, where Hawkins renamed the company the Ensemble Theatre. In 1985, the Ensemble moved into its current space, a former car dealership at 3535 Main Street, in what is now referred to as MidMain. In 1993, the company soon raised money to buy the space and convert it into a complete theater. Its Performing Arts Education Program provides educational workshops, artist-in-residence experiences and live performances for students both off-site and at the theater, and the Young Performers Program offers intensive spring and summer training in all disciplines of the theater arts. In 2004, the Ensemble Theatre was made a designated stop on the new MetroRail line.

JUNE 4, 1987

Menil Collection Ribbon Cutting

John and Dominique de Menil fled Europe with their young children at the outset of World War II and built a life in Houston, running Dominique's family business, Schlumberger. The two found their life's work championing humanitarian causes and sharing their art collection through education and philanthropy and in alliances with the University of St. Thomas and later with Rice University. Dominique exposed Houstonians to countless visual artists, bringing René Magritte, Marcel Duchamp, Mark Rothko and Andy Warhol to visit Space City. Following her husband's death, Dominique de Menil worked with architects on designs for a permanent home for the couple's art collection. Italian architect Renzo Piano designed the private art museum in Montrose adjacent to the Rothko Chapel and the University of St. Thomas, surrounded by bungalows (many of which were owned by de Menil). Piano stated that the building is a portrait of Dominique de Menil herself. With its modest scale and unpretentious execution, the Menil Collection is a study in restraint. On this day in 1987, Dominique de Menil cut the ribbon on her instant landmark, which she loved to say was "larger on the inside." The Menil is now known worldwide for its collection of Modernist and indigenous art. The campus would grow to include the Byzantine Chapel, Twombly Gallery, Richmond Hall, the Menil Drawing Institute, a bookstore and a bistro. While not Dominique de Menil's last project, this would be the one for which she's most remembered.

JUNE 5, 1837

City of Houston Chartered

Today in 1837, the city of Houston was incorporated, but the official birthday remained August 30, 1836. The new municipal government included a mayor, treasurer, tax collector and eight aldermen. When the original four wards were established in 1840, each would have two elected aldermen as representatives.

JUNE 6, 1980

Urban Cowboy Opened in Movie Theaters

Today in 1980, *Urban Cowboy*, shot and set in Pasadena and Houston, opened in theaters. Based on the 1978 *Esquire* magazine story "The Ballad of the Urban Cowboy: America's Search for True Grit," the movie tapped into a national surging interest in country music (both the movie and soundtrack were hits). John Travolta, fresh off blockbusters *Saturday Night Fever* and *Grease*, plays Bud, a country kid who moves to the city to find work at an oil refinery and is lookin' for love down at Gilley's, the "World's Largest Nightclub." Almost immediately, western wear became the go-to fashion for nightlife creatures burned out on glittery disco (although this version of county and western had plenty of feathers, fringe and glitter). The night before, the world premiere screened at the Gaylynn Theater in Sharpstown Mall and

Urban Cowboy movie poster. *Author's collection.*

was followed by a bash at Pasadena honky-tonk Gilley's with stars Travolta and Debra Winger, joined by club co-owner Mickey Gilley, Andy Warhol and Houston's most famous socialite, Lynn Wyatt. Even though Gilley's closed in 1989, visitors to Houston still ask if the famous mechanical bull is still throwing cowboys.

JUNE 7, 1869

First German Volkfest

European political and economic instability convinced many to seek out the freedom of Texas. German immigration was constant in the first decades of Houston, and Frost Town, east of Allen's Landing, became home to the German community. Founded in 1860, Houston's German Volkfest Association held its first parade and festival on this day in 1869 at Lubbock's

Grove. In 1887, the Volksfest bought a thirty-four-and-a-half-acre park, where it built a large stage and baseball field and cultivated a field for Texas flowers. By 1889, the Bayou Street Railway Company had created a mule car route to the popular destination.

JUNE 8, 2001

Tropical Storm Allison
Today in 2001, Tropical Storm Allison finished a weeklong rain in Houston, causing $5 billion in damage. The slow-moving but powerful tropical storm caused catastrophic flooding in Houston, especially in the tunnels and basements of Downtown and the Medical Center. Portions of below-grade Southwest Freeway in Neartown that were being rebuilt became lakes for several days. Allison was responsible for forty-one deaths (and the later addition of monstrous floodgates in those tunnels and basements).

JUNE 9, 1940

Last Streetcar
Today in 1940, due to the popularity of buses and automobiles, the last electric streetcar ended service after seventy years. Starting in 1868, mule-driven rail cars carried passengers around Downtown. In the early twentieth century, electric streetcars replaced mule cars and led to the rapid growth of "streetcar suburbs" such as Houston Heights, Westmoreland and Bellaire. Houstonians would wait until 2004 to see municipal rail service return to city streets, when Metro opened its 7.5-mile Main Street Line.

JUNE 10, 1841

Port of Houston Founded
As the ship *Laura* proved in 1837, Houston could be the head of navigation for Buffalo Bayou and thus a commercial destination. On this day in 1841, Houston City Council established the Port of Houston to control wharves,

landings and roads along the banks of Buffalo Bayou and empowered the port to collect fees and make physical improvements. Thereafter, steamboats would regularly dock at the foot of Main Street for commerce. Houston was open for business and would constantly make commercial improvements to the waterway through railroads, bridges, tunnels, widening, straightening and dredging.

JUNE 11, 1838

Houston's First Theater Opened

Even in the earliest days of Houston, there was never a shortage of entrepreneurs. Looking to open a theater, John Carlos bought a building at Main and Franklin for a future performance space. When Henri Corri and his traveling theater troupe arrived on the banks of Buffalo Bayou, they found a willing host in Carlos. Today in 1838, the John Carlos Theater opened to a sold-out house with productions of *The Hunchback* and *The Dumb Belle*, and Henry Corri debuted his "New National Texan Anthem." President Sam Houston himself, quite a theatrical person in his own right, saw the production during its months-long run.

JUNE 12, 1891

First Electric Rail Car

Banker Oscar M. Carter, seeing late nineteenth-century Houston as a viable commercial center, bought two existing mule car rail lines and merged them into the Houston City Street Railway Company. After getting the franchise rights from City Council, Carter built an electric trolley network on Downtown's muddy streets. On this day in 1891, city and county officials rode in Houston's first electric streetcars. Regular service began days later on June 15. Carter later founded Houston Heights (and made sure his trolley lines ran there too).

JUNE 13, 1983

Pioneer 10

On this day in 1983, NASA's unmanned U.S. space probe Pioneer 10 became the first spacecraft to leave our solar system. It was launched in March 1972 and transmitted the first up-close images of the planet Jupiter. By 2003, after more than thirty years, the spacecraft had sent its last signal to Earth, after Pioneer 10's radioisotope power source decayed. Still traveling on its last trajectory, Pioneer 10 is now over eight billion miles away from home. And yes, Pioneer 10 is the "space garbage" blasted by the Klingons in *Star Trek V.*

JUNE 14, 1995

Houston Rockets Won Their Second NBA Championship

Reigning NBA champions the Houston Rockets were not favored to repeat in 1995, but many non-believers were convinced when Clyde Drexler, Hakeem's Phi Slama Jama teammate and a native Houstonian, was traded to Houston mid-season. Fans were thrilled, but the Rockets finished that season having won eleven fewer games than they had the year before, and they entered the playoffs as a six-seed, without home court advantage in any of the matchups. (It's never easy in Houston.) When the Rockets entered the 1995 NBA finals, the Orlando Magic were favored to win it all, led by marquee players Shaquille O'Neal and Anfernee "Penny" Hardaway.

On this day in 1995, the Houston Rockets swept the Magic in four games and won their second NBA Championship. And just like in 1994, Hakeem won the finals MVP Award. The entire city was filled with joy witnessing Clyde the Glide and Hakeem the Dream finishing what they hadn't been able to eleven years earlier in college. The night and season were best summed up by head coach Rudy Tomjanovich, who said at the end of the 1995 finals, in the most famous quotation in Houston sports history, "Don't ever underestimate the heart of a champion!"

JUNE 15, 1976

Astrodome Rain-In

Houston may have invented indoor baseball, but that didn't mean the Astrodome was immune from the dreaded rain-out. On this day in 1976, a summer rainstorm struck Houston, flooding the streets around the Astrodome and adjacent Texas Medical Center. Astros general manager Tal Smith decided to postpone the game for the safety of fans and employees, even though the umpires were no-shows. Both Astros and visiting Pittsburgh Pirates, who had arrived hours earlier, dined on tables set up on the field. Players, staff and the few fans who made it to the Dome left when the waters receded after a few hours.

JUNE 16, 1977

Gay Community Galvanized

In the summer of 1977, gay rights opponent Anita Bryant was invited to perform at the Texas State Bar Association's annual convention. When

Houston's gay community heard the nation's leading anti-gay voice would be speaking in Houston, the once-fractured group mobilized into a united front. Fliers invited gay and "non-gay friends" to meet in a nonviolent demonstration because "anything to the contrary could do immense harm to the Gay Movement." On this day in 1977, nearly three thousand gay, lesbian and straight Houstonians gathered at a Midtown bar and marched peacefully Downtown, past the site of the convention, to a rally at the Houston Public Library, where the crowd grew to over eight thousand.

Author's collection.

JUNE 17, 2017

Emancipation Park Rededicated

The anniversary of the day enslaved African Americans in Texas learned of their emancipation in 1865 became known as Juneteenth. Seeing the need for a site to celebrate Juneteenth, Houstonian Reverend Jack Yates, a Baptist minister and former slave, led local fundraising for the Colored People's Festival and Emancipation Park Association. In 1872, they paid $1,000 for ten acres of open land in the Third Ward for future Juneteenth celebrations, naming it Emancipation Park. The City of Houston acquired it in 1916, and in a racially segregated city, Emancipation Park was the only municipal park African Americans could use. In 1939, the Works Progress Administration built a community center building, swimming pool and bathhouse in Emancipation Park. Suffering from years of inconsistent support, Emancipation Park developed a plan for redevelopment with support from the OST/Almeda Redevelopment Corridors TIRZ #7, the Emancipation Park Conservancy and the Houston Parks and Recreation Department. The comprehensive $35 million upgrade included a new recreation center, renovation of the existing community center and bathhouse, a new swimming pool, reconfigured parking, a playground, a walking trail, tennis and basketball courts and a ball field. On this day in 2017, Mayor Sylvester Turner rededicated Emancipation Park.

JUNE 18, 1938

The Heights Voted to Remain Dry

Since 1891, local option elections allowed Texas counties, precincts and towns to decide by majority "whether the sale of intoxicating liquors for beverage purposes shall be prohibited or legalized within the prescribed limits." An election in the Houston Heights in 1912 affirmed the independent community's desire to stay "dry." However, in 1918, following the Heights' annexation by the City of Houston, that status was cast in doubt. In 1937, the Texas Supreme Court affirmed the original boundaries for the Heights (now Houston) could stay dry until another local option election was held. On this day in 1938, three years after the repeal of Prohibition was ratified in Texas, the Heights voted (1,113–1,444) against legalizing alcoholic beverages. The Heights would stay dry until 2016, when residents voted

to allow stores to sell alcoholic beverages, and in 2017, residents voted to allow restaurants to serve alcohol (and without the "private club" loophole that had existed for decades).

JUNE 19, 1865

Juneteenth

On September 22, 1862, President Abraham Lincoln signed the Emancipation Proclamation. When it was issued on January 1, 1863, it effectively abolished slavery, freeing over three million enslaved African Americans. Sadly, word of it reached Texas nearly two years later, when General Gordon Granger read "General Order No. 3" aloud publicly in Galveston on this day in 1865.

> *The people of Texas are informed that, in accordance with a proclamation from the Executive of the United States, all slaves are free. This involves an absolute equality of personal rights and rights of property between former masters and slaves, and the connection heretofore existing between them becomes that between employer and hired labor. The freedmen are advised to remain quietly at their present homes and work for wages. They are informed that they will not be allowed to collect at military posts and that they will not be supported in idleness either there or elsewhere.*

The anniversary of this day quickly became known as "Juneteenth" for African Americans throughout Texas. Celebrating the new holiday was difficult in segregated Houston, where no parks allowed African Americans to congregate. In 1872, Houston clergyman Reverend Jack Yates led a fundraising effort to buy ten acres of land as home for Juneteenth celebrations, naming the site Emancipation Park. In 1979, the State of Texas declared Juneteenth to be a state holiday. Since then, many other states have begun observing Juneteenth, and Americans of all races observe the day of freedom.

JUNE 20, 1865

Civil War Aftermath
Texas Confederate forces grudgingly accepted defeat on June 2, 1865. Weeks later, the Union army's General Gordon Granger arrived at Galveston with word of Confederate surrender and emancipation of enslaved African Americans. On this day in 1865, Union forces occupied Houston to ensure peaceful readmission of Houstonians to United States citizenship, but reconciliation would take decades for many who stayed loyal to the antebellum ways of life. The federal government would eventually assert a more permanent presence in Houston and Texas during the Reconstruction era.

JUNE 21, 1913

Houston Symphony Orchestra
Today in 1913, the Houston Symphony Orchestra debuted with a concert at the Majestic Theatre. Newspaper advertisements coaxed Houstonians with, "Your first opportunity of expressing your wish for this new acquisition to Houston's greatness. Express yourself by your presence." The well-attended and well-received show encouraged founder Ima Hogg to host a demonstration concert later that year, which proved that Houston could be home to permanent cultural institutions such as a residence symphony. Miss Ima would spend the rest of her life sustaining the Houston Symphony.

JUNE 22, 1994

Rockets' First Championship
Very little in the Houston Rockets' 1993–4 season gave fans the sense that they would go all the way to the NBA finals. Sure, they had future MVP Hakeem Olajuwon, who, after a painful championship loss in 1986 and ten years with Houston, was hungry to show he was the best player in the NBA. In the summer of 1993, Les Alexander bought the team for $85 million. Fueled by head coach Rudy Tomjanovich, then in his second full season, the Rockets became a reenergized team and set a franchise record with fifty-eight winning games. Houston made it through the playoffs and would be

matched up with the New York Knicks in the NBA finals, pitting two of the game's best centers of all time—Hakeem Olajuwon and Patrick Ewing. After the Houston Rockets blew leads in the first two games, the *Houston Chronicle* mocked the losses with the humiliating but accurate headline "Choke City." Game five was interrupted by coverage of the slow-speed chase involving Los Angeles police and O.J. Simpson's white Ford Bronco, and play was pushed into a small box at the bottom of the TV screen, thus reminding Houston of that old cliché, "The national news media never gives us any respect." Never did a Houstonian feel that more acutely than during the final game. Minutes before tipoff in game seven of the 1994 NBA Championship, television commentator Bob Costas presented a montage of misery—video clips of painful Houston sports losses new and old, including Astros and Oilers. He captured what all Houston sports fans felt in his history lesson. However, after leading the team in points, rebounds and assists, Hakeem dominated game seven, with the Rockets beating the Knicks and giving Houston its first major championship. And the city lost its collective mind. Car horns blared for hours after the final buzzer sounded, and strangers embraced one another in celebration. Oh, and that cheap shot Choke City line? It was reborn as Clutch City—a proud nickname still used today.

JUNE 23, 2003

Rice Won College World Series

Today in 2003, with a 14–2 win over Stanford, the Rice Owls won the College World Series, the university's first national title in any sport—quite a feat for a school known for academic excellence. While not exactly underdogs, Rice had been thwarted in three previous trips to the College World Series in Omaha, Nebraska.

JUNE 24, 1918

City of Bellaire

In 1908, William Wright Baldwin's South End Land Company, developer of the subdivision Westmoreland, bought nine thousand acres southwest of Houston's city limits for a new community dubbed Westmoreland Farms. Within this site, the town of residences and small farms was laid out, connected

to Houston by Bellaire Boulevard and its trolley. On this day in 1918, with a population of nearly two hundred, the city of Bellaire was chartered. Today, Bellaire operates under a council-manager form of government, providing services that include police, fire, municipal court, building construction, water, wastewater, sanitation and parks. Like adjacent municipalities West U and Southside Place, Bellaire has successfully resisted annexation by Houston, which now borders it to the north, south and west.

JUNE 25, 1926

Jesse Jones Assumed Control of the *Houston Chronicle*

In 1906, Jesse Jones was eager to grow his fortune beyond lumberyards and sawmills. After buying a half interest of land owned by *Houston Chronicle*'s founder M.E. Foster, Jones built the *Houston Chronicle* building for the young daily newspaper. On this day in 1926, Jesse Jones, following years of editorial and political disagreements with Foster, bought the other half of the paper. Jones and, later, his Houston Endowment owned the *Houston Chronicle* until 1987, when the Hearst Corporation bought it for $400 million.

JUNE 26, 1928

Democratic National Convention

Democratic Party bigwig Jesse Jones was personally responsible for bringing the Democratic National Convention to Houston. On this day in 1928, with the national spotlight on the Bayou City, the Democratic National Convention convened at the brand-new Sam Houston Hall. Twenty-five

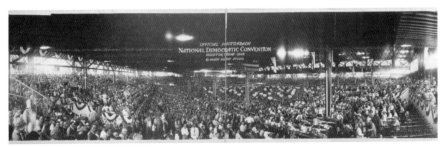

Democratic National Convention. *Courtesy of the Library of Congress.*

thousand visiting delegates, politicians and journalists descended on Houston vthat summer. Proving his popularity, Jones was even asked to be presidential nominee Al Smith's running mate, but "Mr. Houston" wasn't interested in being a politician. Future mayor Roy Hofheinz began a decades-long friendship with future president Lyndon Johnson at the multiday event.

JUNE 27, 1918

Hortense Sparks Ward Registered to Vote

Houston lawyer Hortense Sparks Ward, one of the first women admitted to the State Bar of Texas, was an instrumental figure in the women's suffrage movement in Texas. In 1918, Ward successfully lobbied Governor William Hobby and the Texas legislature to ratify the Nineteenth Amendment to the U.S. Constitution, giving women the right to vote. On this day in 1918, Ward became the first woman to register to vote in Harris County. She continued by getting over 300,000 women registered to vote and later ran unsuccessfully for Harris County judge. She would eventually hold a series of temporary judicial positions.

JUNE 28, 2016

Astrodome Renovation Plan Approved

After years of fanciful proposals and a failed $217 million renovation bond election, the Astrodome and its caretakers, the Harris County Commissioners Court, settled on a plan to convert Houston's erstwhile signature landmark Astrodome into a multi-use space. As built, the Dome's playing field sat twenty-five feet below street level. The court's no-new-tax plan was to raise the floor of the Astrodome, with parking spaces underneath, and open the new floor to conventions, conferences, festivals, fairs or other revenue-generating events. Today in 2016, Harris County Commissioners Court voted unanimously to advertise for a construction manager who would get a specific construction cost estimate. Months later, the Texas Historical Commission designated the Astrodome a state antiquities landmark, which gave the beloved stadium protections from demolition. In February 2018, the court, led by County Judge Ed Emmett,

agreed to the funding from three sources: $35 million from the general revenue (already drawn from property tax revenues), $35 million from hotel occupancy taxes and the final $35 million kicked in by Downtown parking revenue. For Domers and preservationists, this was the clearest sign that the Astrodome was, in fact, saved.

JUNE 29, 1986

The Orange Show's Road Show

In 1984, Houston artist Jackie Harris decorated a 1967 Ford station wagon for an Orange Show fundraiser. Her "Fruitmobile" became a symbol for the fun and funky programming done by Susanne Theis and Sharon Kopriva at the Orange Show. Today in 1986, the Orange Show hosted "Road Show," where eleven painted, decorated or altered art cars were exhibited alongside the Fruitmobile. In 1988, with support from the annual Houston International Festival, the Orange Show created "Roadside Attractions: The Art Car Parade," which would later grow to be the nation's largest Art Car parade and one of Houston's signature annual events.

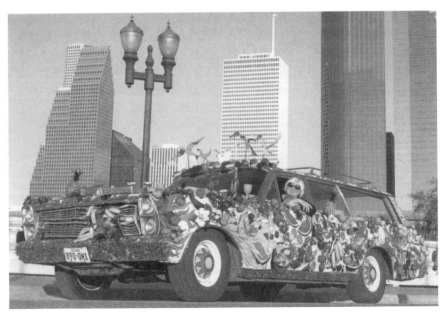

Fruitmobile and Jackie Harris. *Courtesy of Harrod Blank.*

JUNE 30, 2014

Sports Illustrated Picked the Astros to Win the World Series...in 2017

Today in 2014, *Sports Illustrated* picked the Houston Astros to win the 2017 World Series. Whether it was a legitimate prediction or a simple case of being provocative in order to sell magazines, the cover article, by Ben Reiter, did get baseball fans talking, mostly because the Astros were fresh off of three straight seasons of one hundred or more losses. Reiter examined the team's new philosophy and heavy focus on analytics, spearheaded by general manager Jeff Luhnow and authorized by new owner Jim Crane, who understood that winning in the future meant lots and lots of losing in the present. The losing seasons meant the Astros could stockpile high draft picks, which they would use on cornerstone players like Carlos Correa and Alex Bregman. And with players like Jose Altuve and *SI* cover boy George Springer already on the team, positive results came even sooner than expected. The Astros made the playoffs for the first time in a decade in 2015 and were fashionable picks to make the World Series in 2016. (*SI* even picked them to win it all that season, a year ahead of its original forecast.) It all paid off in 2017 with the first World Series win in franchise history, making the *Sports Illustrated* cover seem downright prophetic.

JULY

JULY 1, 1979

First Gay Pride Parade

Throughout the 1970s, gay and lesbian civil rights groups grew in size and influence throughout the United States, and nationwide gay pride weeks, typically held near the June anniversary of 1969's Stonewall uprising in New York City, were celebrated in many American cities. Houston's first gay pride week was organized in 1978, but on this day in 1979, Houston's first official gay pride parade rolled down Lower Westheimer with banners declaring "United We Stand." In subsequent years, the pride parade would grow to include floats and marching bands, reschedule to nighttime and become the signature Montrose party. By 2015, the parade would outgrow Montrose's narrow streets, moving Downtown, but the celebration still enlivens all of Montrose.

JULY 2, 1883

Alfred Finn Was Born

On this day in 1883, Houston architect Alfred C. Finn was born. Finn designed mansions for oil tycoons and shaped young, booming Houston's Downtown skyline, with the iconic Gulf Building, the Sam Houston Coliseum and an addition to the Rice Hotel. He also designed University

of Houston's Ezekial Cullen Building and the towering memorial obelisk the San Jacinto Monument.

JULY 3, 1954

One Million in Harris County

Today in 1954, Harris County got is 1 millionth resident. Although various booms had hit the area throughout the twentieth century, the city of Houston would reach one million residents in 1961. In present day, Houston is constantly replenished with "Newstonians," making it the fourth-largest city population in the United States.

JULY 4, 1962

Astronaut Barbecue

Houston welcomed the original seven Project Mercury astronauts, their families and nearly seven thousand employees of NASA's Manned Space Center to town with a parade and indoor barbecue at Downtown's Sam Houston Coliseum. The newly minted astronauts, who had all moved to Houston to train for their spaceflight missions, were given Stetsons and big welcomes from every city and state politician. Even Vice President Lyndon Johnson joined the party.

Mercury astronauts at the NASA barbecue. *Courtesy of NASA.*

JULY 5, 2006

Ken Lay Dead

Enron, the world's largest energy trading company, filed for bankruptcy on December 2, 2001—becoming the largest-ever bankruptcy to date. By the time CEO and chairman Ken Lay was asked to resign by the creditors' committee, Enron's turnaround was impossible, and collapse was nearly complete. Investigators eventually found that Lay, Jeff Skilling and others had authorized concealing debt from shareholders and investors. In 2006, Lay, who had started Enron in 1986, was found guilty of securities fraud. On this day in 2006, Ken Lay died while on vacation, before he could be sentenced for his crimes, which meant the verdict would be later vacated, infuriating many of his victims who had lost their pensions in the scandal.

JULY 6, 1990

Zina Garrison at Wimbledon

Today in 1990, native Houstonian Zina Garrison beat Steffi Graf in the Wimbledon semifinals, becoming the first African American woman to reach a Grand Slam tournament singles final since Althea Gibson in 1958. Garrison, who would eventually lose to Martina Navratilova in the final, ended her career in 1997 with fourteen singles titles, twenty in doubles, three Grand Slam titles in mixed doubles and gold and bronze Olympic medals. She also founded the Zina Garrison All-Court Tennis program for children, operating at various Houston public tennis courts, including MacGregor Park, where a ten-year-old Garrison discovered her love of the sport.

JULY 7, 2000

Continental Club Opened

On this day in 2000, live music venue the Continental Club hosted its first show—Mojo Nixon. Taking its cues from Austin's Continental Club, the Houston version would be larger and in an untested neighborhood. Investors knew the MetroRail would be built soon after doors opened, but no one could be certain audiences would find the place in the run-down,

forgotten 1920s brick building across from the Ensemble Theatre (the term "Midtown" had not taken off at that point). Early years saw Monday night bingo and a rotating schedule of musical acts shared with Austin's Continental Club—and most played in each other's bands. Houston musical legends Archie Bell, Roy Head and Trudy Lynn still perform there occasionally. Today, the club is surrounded by restaurants, hipster stores, coffee shops, upscale apartments and MATCH (the Midtown Arts & Theater Center Houston). The mini-hood is lovingly referred to as MidMain, and Continental Club remains Houston's most stubbornly authentic live music venue.

JULY 8, 1876

City Hall Fire

Today in 1876, Houston's second City Hall and Market House suffered a catastrophic fire. The wood structure, built in 1872, featured two towers and a theater. Mayor Thomas Scanlan, a Reconstruction appointee, took the blame for Houston's largest fire to date. Because the City Hall was underinsured, the replacement was modest in comparison (and that one would burn down in 1901).

JULY 9, 1990

G7 Summit

Today in 1990, the sixteenth G7 Summit opened in Houston. Former Houston congressman and sitting U.S. president George H.W. Bush welcomed members from the Group of Seven—political leaders of Canada, France, Italy, West Germany, the United Kingdom, Japan and the head of the European Commission—to the campus of Rice University for three days of meetings. The opening day barbecue featured all the great and not-so-great stereotypes of Texas. On the closing day, President Bush declared, "We are united in a common goal to extend to those who seek political and economic freedom a helping hand with our resources, talents and experience. As our declaration states, when people are free to choose, they choose freedom." The Lights Spikes installation, now at the entrance

G7 Summit at Rice University. *Courtesy of Rice University.*

to Bush Intercontinental Airport, was commissioned for the summit to commemorate the participating nations.

Bush's ties to Houston reach back to 1959, when he moved his family and young oil company there. In the newly created Seventh Congressional District of Texas, Bush represented conservative west Houston and was the first Republican from Houston to go to the House of Representatives. Following his two terms in the House of Representatives, George H.W. Bush filled appointed roles for Republican presidents Nixon and Ford and, in 1980, joined Ronald Reagan as his running mate. In 1988, he won the presidency and was always proud to show Houston to the world at events like the G7 Economic Summit and the 1992 Republican National Convention. Out of office, he and his wife, Barbara Bush, split their time between their residence in Tanglewood and the family home in Kennebunkport, Maine. In 1997, Houston Intercontinental Airport was renamed for him. The couple remained the most famous Houstonians throughout the rest of their lives. In 2018, Barbara Bush passed away, and months later, George H.W. Bush followed her. After days of observance and services in Washington, D.C., and Houston, the president was laid to rest near his wife and daughter at his presidential library in College Station.

JULY 10, 1882

Ima Hogg Was Born

On this day in 1882, Ima Hogg was born. The daughter of Texas governor Jim Hogg and sister to River Oaks developers Will and Mike Hogg, Ima Hogg made her own mark on Houston with her high standard for philanthropy, civic engagement and preservation. In 1913, she organized the Houston Symphony Orchestra, and she spent the rest of her life as its benefactor and governing visionary. She filled her River Oaks home, Bayou Bend, with art and antiques. Since 1966, the Bayou Bend Collection house museum has been owned by the Museum of Fine Arts–Houston. She was famously known as "Miss Ima" and the "First Lady of Texas."

JULY 11, 1979

Rockefeller's Opened

In a town not known for its preservation of landmarks, the neoclassical bank at 3620 Washington has had many lives. The Joseph Finger–designed Citizens State Bank opened in 1925 and was later renamed Heights State Bank. On this day in 1979, Susan and Sanford Criner opened Rockefeller's, a small music venue for jazz, blues, folk and rock concerts, with Houston singer-songwriter Danny Everitt on stage for the first show. The bank was remade with a stage, bar and balcony, but little change was made to the conservative façade. Houston already had the Music Hall, the Summit and even the Astrodome for its large shows, and Rockefeller's joined Anderson Fair, Fitzgerald's, Number's and Cardi's for smaller and up-and-coming bands. By the late 1990s, as Washington Avenue was on the verge of a renaissance, Rockefeller's closed. Soon, sisters Lisa Porter and Cynthia Porter Davis reopened it as Rockefeller Hall, a private event facility. The legendary venue Rockefeller's returned to hosting musical acts in 2016.

JULY 12, 1976

Barbara Jordan Delivered Keynote Address

Today in 1976, Houston congresswoman Barbara Jordan delivered the keynote address at the Democratic National Convention, the first African American to do so. Hers was the brightest moment that week when she declared to a wounded country, "Are we to be one people bound together by common spirit, sharing in a common endeavor; or will we become a divided nation? For all of its uncertainty, we cannot flee the future....We must address and master the future together. It can be done if we restore the belief that we share a sense of national community, that we share a common national endeavor. It can be done."

She left Congress in 1979 and moved to Austin to teach at the University of Texas's Lyndon B. Johnson School of Public Affairs. The honors poured in. The Barbara Jordan High School for Careers opened in the Fifth Ward, along with others in Texas. She was even invited back to the Democratic National Convention in 1992 for another keynote address and delivered her message of hope—from a wheelchair. Multiple sclerosis slowed her, but not by much.

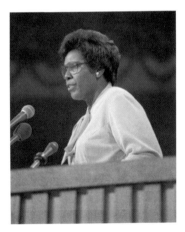

Following her death after a long illness in 1996, President Bill Clinton and Governor Ann Richards spoke at her funeral. She was buried in the Texas State Cemetery—again, the first black woman to be so honored. Austin, a home to her since returning from Congress, erected *two* Barbara Jordan statues (thanks, Austin). In 2011, the U.S. Postal Service honored the late United States congresswoman Barbara Jordan with a stamp; she was the second Houstonian to receive this honor.

Representative Barbara Jordan speaking at the Democratic National Convention, July 12, 1976. *Courtesy of the Library of Congress.*

JULY 13, 2004

All-Star Game

Houston had hosted the MLB All-Star Game on two previous occasions, in 1968 and 1986. But both of those events had been at the Astrodome; this was the first time Minute Maid Park would welcome baseball's best players for its annual mid-season exhibition game. And the hometown Astros, then in the National League, were well represented in the festivities. Lance Berkman was the runner-up in the previous day's Home Run Derby, and he replaced an injured Ken Griffey Jr. in the starting lineup for the game itself. Second baseman Jeff Kent was voted a starter by the fans, while Roger Clemens was selected as starting pitcher by National League manager Jack McKeon. The Astros even inherited an All-Star, as newly acquired outfielder Carlos Beltran, voted on to the American League squad for his time with the Kansas City Royals, was allowed to play on his new team in his new league. Muhammad Ali, no stranger to town, threw out the ceremonial first pitch, and legends like Derek Jeter, Albert Pujols and Barry Bonds were all in the starting lineup. Ultimately, Clemens had one of his worst ever outings, giving up 6 runs in a single inning for the first time in his career, and the National League lost, 9–4.

JULY 14, 1805

Charlotte Baldwin Allen Was Born

Today in 1805, Charlotte Baldwin, who would later marry Houston co-founder Augustus Allen and become known as the "Mother of Houston," was born in New York State. When Augustus and his brother John Kirby Allen traveled up Buffalo Bayou in 1836 looking for land to develop, they found the future site of the city of Houston. With money from Charlotte, whose father was a land developer himself, the Allen brothers bought over six thousand acres at the confluence of Buffalo and White Oak Bayous. Naming their new venture after the leader of the Texian Army and the hero of the Battle of San Jacinto, Sam Houston, the Allen brothers promoted the new town to settlers in the Republic of Texas. John Kirby Allen died in 1838 with no heirs, with his portion of Houston land and investments going to brother Augustus. After Charlotte and Augustus separated in 1850, he left Houston and deeded all of his property to her. Charlotte Allen lived

the remainder of her life in Houston as a land developer, businesswoman, philanthropist and hostess. When she died in 1895, flags flew at half-staff for the "Mother of Houston." She was laid to rest in Glenwood Cemetery.

JULY 15, 2008

Dr. Michael DeBakey Died

Today in 2008, the casket of renowned surgeon and medical innovator Dr. Michael DeBakey, who died days earlier a few weeks shy of one hundred, was placed in City Hall, where an estimated two thousand Houstonians paid their respects. He remains the only person to receive that honor. During World War II, he helped develop mobile army surgical hospital (MASH) units; was a major contributor to the creation of the Veterans Health Administration Hospital System; improved the National Library of Medicine; chaired the President's Commission on Heart Disease, Cancer and Stroke; and served serve three terms on the National Heart, Lung and Blood Advisory Council of the National Institutes of Health. Among his many awards and recognitions were the Lasker Foundation medal, the Presidential Medal of Freedom with Distinction (the highest civilian award a United States citizen can receive) and the Congressional Gold Medal. Houston institutions that bear his name are the Michael E. DeBakey VA Medical Center, the Michael E. DeBakey High School for Health Professions, Baylor College of Medicine's Michael E. DeBakey Department of Surgery and the Methodist DeBakey Heart and Vascular Center. Dr. Michael DeBakey was buried at Arlington National Cemetery.

JULY 16, 1988

The Fastest Man Alive

Today in 1988, at the American Olympic trials in Indianapolis, Houstonian Carl Lewis finished the 100-meter dash in 9.96 seconds, in two different attempts, the world's fastest that year. Later, the fastest 100 meters in any condition to date was recorded at 9.78 seconds but was marred by controversial headwinds, which were blowing at 5.2 meters per second. Lewis headed into these trials with four gold medals from the 1984 Olympics

in Los Angeles, and just the previous year, the track star had his best time with 9.93 seconds. The University of Houston alumnus would go on to compete in the 1988 Seoul Olympics, winning gold in the 100 meters (after Ben Johnson, who beat him, was found to be doping) and the long jump and silver in the 200 meters. By the time he retired in 1996, the Houston resident would have nine gold medals.

JULY 17, 2017

Rockets for Sale

Today in 2017, Houston Rockets owner Les Alexander announced that he intended to sell the team he had owned for more than two decades. Alexander purchased the Rockets in 1993 for $85 million and watched as they won back-to-back NBA titles the following year. During his time as owner, Alexander brought Clyde Drexler back home, acquired Chinese star Yao Ming and helped get the Rockets into the Downtown arena the Toyota Center. In 2017, restaurant and casino owner Tilman Fertitta bought the team for $2.2 billion, a new record-high price for a professional basketball franchise.

JULY 18, 1966

Gemini 10

Throughout the 1960s, NASA worked toward the goal of putting a man on the moon. Project Gemini, with its two-man crews, sought to advance understanding of procedures that would be used on future moon shots. Gemini 10's mission was to rendezvous with an abandoned booster in low orbit and then blast to a higher orbit. On this day in 1966, astronaut Michael Collins made the first free spacewalk between two spacecrafts and retrieved a package from another orbiting object, and he and command pilot John Young set an altitude record for human flight. Collins would go on to pilot the command module in the Apollo 11, and Young would go on to fly to the moon twice and command the first space shuttle mission in 1981.

JULY 19, 2008

Comicpalooza Launched

On this day in 2008, in the lobby of the Alamo Drafthouse Theater in Katy, Comicpalooza debuted. Although it was organized as an autograph signing to coincide with the release of the movie *The Dark Knight*, the event drew five hundred people. The next year, Comicpalooza grew into a two-day comic book festival with special screenings, Q&A sessions and an art benefit. In 2010, after moving into the George R. Brown Convention Center, Comicpalooza morphed into a massive convention and fan show celebrating science fiction, fantasy, horror, steam punk, New Media, film and gaming. Now one of the largest conventions in Houston, it boasts forty thousand annual attendees, more than two thousand hours of programming and over one million square feet for exhibits, vendors, panel discussions and celebrity appearances.

JULY 20, 1969

Moon Landing

Today in 1969, NASA landed the first humans on the moon. While Michael Collins orbited overhead in the Apollo command module, astronauts Neil Armstrong and Buzz Aldrin landed on the lunar surface. As any proud

Houstonian will tell you, Apollo 11's first transmission back to Earth was, "Houston, Tranquility Base here, the Eagle has landed." As Armstrong exited the lunar module and set foot on the surface, billions heard him declare, "That's one small step for [a] man, one giant leap for mankind." Armstrong and Aldrin planted an American flag and collected soil and rock samples; before returning to command module, they left a plaque that bore the inscription, "Here Men from Planet Earth First Set Foot Upon the Moon. Jul. 1969 A.D. We Came in Peace for All Mankind."

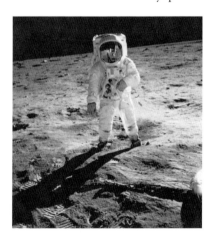

Astronaut Buzz Aldrin on the moon. *Courtesy of NASA.*

Apollo 11 fulfilled President Kennedy's pledge earlier in the decade to put men on the moon. NASA would eventually put twelve men on the moon before the Apollo program ended in 1972.

JULY 21, 1973

Townes Van Zandt Recorded His Masterpiece

Fort Worth native singer-songwriter Townes Van Zandt played so many gigs in Houston that most thought he was a local. His debut record dropped in 1968, but years later, Van Zandt was still struggling to find the larger audiences he deserved. Either out of desperation or inspiration, he planned a live album in a little bar not far from the Harris County Jail. Today in 1973, Townes Van Zandt was midway through a multiday recording of what would become *Live at the Old Quarter, Houston, Texas*, a two-disc masterpiece that captured beautifully his bluesy sorrow and wry twang, with just a voice and a guitar. The album was released in 1977 and reminded everyone why Van Zandt was so great. In 1983, Willie Nelson and Merle Haggard took their version of Van Zandt's "Pancho and Lefty" to the top of the charts.

JULY 22, 1837

First Marriage License

On this day in 1837, county clerk DeWitt Harris signed Houston's first marriage certificate, authorizing Mary Smith and Hugh McCrory to wed. They married the next day in a Methodist service. The groom died a few months later, but Smith remarried in 1840 to Republic of Texas president Anson Jones.

JULY 23, 1997

Westmoreland and West Eleventh Place Named Historic Districts

Houston City Council adopted the Historic Preservation Ordinance in 1995 to protect areas that possessed a high concentration of structures or sites with

historical, cultural, architectural or archaeological significance. Today in 1997, weeks after Courtlandt Place was designated the first historic district, Westmoreland and West Eleventh Place joined the list. Westmoreland, developed in 1902 at the southern edge of Houston, with a trolley to the new residential neighborhood, became Houston's first streetcar suburb. Even though the neighborhood declined in the 1950s, Westmoreland retained enough historic homes to qualify it for historic district status. West Eleventh Place, snuggled between Shadyside and Broadacres north of Rice University, was built on a private cul-de-sac, with seven high-end historic houses dating from the 1920s. Today, Houston has twenty-two historic districts and continues to sort out how to balance protection for property owners' rights and for the landmarks that make the districts historic.

JULY 24, 1917

Camp Logan Established

One of Houston's signature places is the woodsy Memorial Park. In a city with few geographical features, the city park reminds visitors that Houston was founded on land where the coastal prairie meets the edge of the piney woods. In the summer of 1917, as the United States' participation in World War I intensified, Houston was chosen as the site for a military installation. Today in 1917, Camp Logan, a U.S. Army training facility, began construction in the current Memorial Park. The City of Houston leased nearly 7,600 acres for various army activities until the spring of 1919. In 1924, the Hogg family bought 1,500 acres north of Buffalo Bayou and sold it to the city for cost so that the public space would become Memorial Park.

JULY 25, 1974

Barbara Jordan Delivered Her "We the People" Speech

Houston native and African American Barbara Jordan was elected to the United States Congress in 1972. During the congressional inquiries into the Watergate scandal in the summer of 1974, she served on the House Judiciary Committee and was a clear voice in the noisy impeachment hearings of President Richard Nixon. On this day in 1974, she famously spoke:

"We, the people." It's a very eloquent beginning. But when that document was completed on the seventeenth of September in 1787, I was not included in that "We, the people." I felt somehow for many years that George Washington and Alexander Hamilton just left me out by mistake. But through the process of amendment, interpretation, and court decision, I have finally been included in "We, the people."…My faith in the Constitution is whole; it is complete; it is total. And I am not going to sit here and be an idle spectator to the diminution, the subversion, the destruction, of the Constitution.

Suddenly, it was crystal-clear that Barbara Jordan represented not just Congressional District 18, or Houston, or even Texas. She represented the nation.

JULY 26, 2015

Craig Biggio Entered the Baseball Hall of Fame

Today in 2015, Astros legend Craig Biggio entered the Baseball Hall of Fame, the first player to do so as a Houston Astro. Biggio had an impressive career spanning twenty seasons, all with the Astros. He amassed over three thousand hits, the most doubles by a right-handed batter and the most times hit by pitch in the modern era. Perhaps most impressively, Biggio was an All-Star at both catcher and second base in his career, a feat that goes unmatched. Biggio was known as a hard worker and great teammate with the utmost respect for the game, and he set the same example (often vocally) for his teammates. He spent years giving back, becoming the national spokesperson for the Sunshine Kids, which helps kids with cancer. In his touching Hall of Fame speech, Craig Biggio thanked practically every person who helped him succeed in baseball—parents, old coaches, teammates, the clubhouse guys…everyone. After growing up in New York, Biggio moved to Houston to play baseball in 1988 and never left.

B-G-O!

JULY 27, 1970

Carl Hampton Died after Shootout with Police

Activist Carl Hampton came to Houston in 1969 to establish a local chapter of the militant civil rights organization Black Panther Party. Finding difficulty from the national office, Hampton called his group instead the People's Party II. Temperatures were running high in Houston and across the nation, especially between police and African American communities. After Bobby Joe Conner, a young African American man, died in police custody, Hampton's People's Party II sought justice and found a specific cause to rally black Houston. In the summer of 1970, the Houston Police Department attempted to maintain order on the Third Ward's Dowling Street, where a certain amount of lawlessness had been growing in response to police harassment. After an earlier standoff with the police, Hampton holed up in the People's Party headquarters. Days later, Hampton emerged to speak to the crowd. Conflicting reports paint a confusing picture—either HPD snipers or Hampton and members of the People's Party shot first. On this day in 1970, Carl Hampton died from a gunshot wound he took from the police during the previous night's shootout. A Harris County grand jury did not indict the police officers for the death of Hampton.

JULY 28, 1985

Urban Animals Rolled

The Urban Animals began rolling through the Houston streets in the late 1970s. Sporting a strong counterculture vibe, the roller skaters and skateboarders wore black (or anything wild) and explored the abandoned streets of Downtown at night. The group would zip down empty parking garages and continue on to Downtown dives and grungy Montrose bars—a pub crawl on four wheels. On this day in 1985, the *Houston Chronicle*'s *Texas Magazine* featured the Urban Animals' public jousting tournament on its cover. Proudly declaring "Skate or Die," the Urban Animals were also featured in the artsy and atmospheric 1985 documentary film *Speed Street* and would roll well into the 1990s. Today, Urban Animals' legacy can be found in roller derby; the younger, more punk spinoff group Skate Trash; and in the annual Art Car Parade.

JULY 29, 1958

NASA Created

On this day in 1958, hot on the heels of the Soviet Union and its booming space program, President Dwight Eisenhower signed the act that created the National Aeronautics and Space Administration (NASA). Its predecessor, the National Advisory Committee for Aeronautics (NACA), had provided the existing Lewis Research Center in Ohio; Langley Research Center and the Wallops rocket test range in Virginia; and Ames Research Center and Edwards Air Force Base in California. Later, Eisenhower would order the transfer of space projects and appropriations from other space programs to NASA, giving NASA a staff of 8,240 and a budget of nearly $340 million. With the help of Houston congressmen Bob Casey and Albert Thomas, the Manned Spacecraft Center would be located in Clear Lake (and later renamed in honor of President Lyndon Johnson in 1973). The site was home to Mission Control or, in astronaut shorthand, "Houston." In the next fifty years, NASA would put a man on the moon, run the Space Shuttle program and assist in building the International Space Station.

JULY 30, 1938

Howard Hughes Parade

Hometown hero Howard Hughes, already famous for his father's oilfield equipment empire and his time as a Hollywood producer, set his sights on aviation. On July 14, 1938, Hughes set a record for flying around the world

in three days, nineteen hours and seventeen minutes. On this day in 1938, Hughes received a hero's welcome when he returned to Houston. After a hearty reception at the Houston airport, which the mayor hastily and illegally named in Hughes's honor, the aviator was greeted to a Downtown parade and banquet at the Rice Hotel.

Howard Hughes parade. *MSS0114-1079, Houston Public Library, HMRC.*

JULY 31, 1974

Union Station Closed

East Downtown's Union Station, once a major hub for commercial and passenger rail, closed on this day in 1974. Houstonians traveling by rail would move to the Amtrak station west of the Downtown post office (where Southern Pacific's Grand Central Station had stood). In present day, the Amtrak station is still there, even though the passenger train stops infrequently in Houston. Union Station, however, was revitalized in 2000 when it was remade into the main entrance for a Downtown baseball stadium—now known as Minute Maid Park. The locomotive above left field is a throwback to the original site.

AUGUST

AUGUST 1, 1976

Life Flight Took Off

On this day in 1976, Hermann Hospital's emergency service Life Flight—a small helicopter equipped to hold a patient, a pilot, a flight nurse and a surgical resident—debuted. It flew three missions that first day and forty-five in the first month. Under the leadership of Dr. Red Duke, the fleet would grow to include three helicopters, each with a three-person crew. Paramedics eventually took the place of physicians, alongside a registered nurse. In 1979, Life Flight added a fixed-wing program to fly patients to and from hospitals worldwide. Today, the Life Flight fleet has six helicopters, equipped with advanced emergency equipment and room for two stretchers, two medical personnel and a pilot.

AUGUST 2, 1952

Gulf Freeway Grand Opening

Dedicated with much fanfare in 1948, Houston's first freeway, U.S. 75 (later designated I-45), would eventually connect Houston to Galveston. Even though not all of it was completed, the Gulf Freeway had its grand opening near Dickinson on this day in 1952. The new freeway had three lanes in both directions in town (down to two closer to Galveston), no

center guardrail, several at-grade crossings and no feeder road. The freeway fueled the development of dozens of southeast Houston suburbs. Constantly growing Houston prompts cynics to wonder, "Has construction ever truly ended?"

AUGUST 3, 1934

Southside Place Established

On this day in 1934, Southside Place, a small community on the southern edge of West University Place, was incorporated. New home construction began in 1925, and the Bellaire Boulevard "Toonerville Trolley" provided access to and from Houston until 1927. Today, Southside Place operates under a council-manager form of government, providing services that include police, fire, municipal court, building construction, water, wastewater, sanitation and parks for its 1,726 residents and over sixty businesses. Like adjacent municipalities West U and Bellaire, Southside Place has successfully resisted annexation by Houston.

AUGUST 4, 1965

Hofheinz Bought the Astros

Houston Sports Association was founded by baseball fans and Houston boosters who sought to bring baseball to town. When former mayor Roy Hofheinz was invited to join, he became partial owner of the Astros. Today in 1965, Hofheinz bought out Bob Smith's shares in the Houston Sports Association, becoming majority owner of the Houston Astros. Hofheinz made the Astrodome his residence with a luxury suite above right field and would go on to build up the so-called Astrodomain to include the Astrohall, AstroWorld theme park and the Astroworld Hotel.

AUGUST 5, 1930

Neil Armstrong Was Born

Today in 1930, astronaut Neil Armstrong was born. In 1962, after joining NASA's astronaut training program, Armstrong and his family moved to the Clear Lake area. In 1969, Armstrong would become the first person to walk on the surface of the moon. In 1979, Downtown's Tranquility Park was dedicated in honor of the Apollo 11 mission and includes a replica of one of Armstrong's lunar footprints.

AUGUST 6, 1974

University of Houston–Downtown College

On this day in 1974, following years of substandard Downtown satellite classrooms, the University of Houston bought the building that housed the private South Texas Junior College for its new University of Houston–Downtown College. In August 1979, the Texas legislature established UH-DC separate from its parent U of H. The school's campus at Allen's Landing included the historic Merchants and Manufacturers Building and the Willow Street Pump Station. In 1983, the school was renamed University of Houston–Downtown (UH-D). Recently, UH-Downtown has discussed an altogether new name.

AUGUST 7, 1989

Congressman Mickey Leland Died

On this day in 1989, Houston congressman Mickey Leland died in a plane crash along with fifteen others in Ethiopia. Days later, U.S. military helicopters found the wreckage of their plane, which had crashed into a mountain. Leland, chairman of the House Select Committee on Hunger, was on his sixth tour of refugee camps along the Ethiopia/Sudan border. The international terminal at Bush Intercontinental Airport; Texas Southern University's Mickey Leland Center for Environment Justice and Sustainability at the Barbara Jordan–Mickey Leland School of Public Affairs; the Mickey Leland Center on World Hunger and Peace; Mickey Leland Memorial Park; and the Mickey Leland Federal Building all honor his legacy.

AUGUST 8, 2OO9

Free Press Summer Fest Debuted

On this day in 2009, Houston's alternative newspaper *Free Press* and local concert promoter Pegstar patched together a two-day, multiple-band music festival in Eleanor Tinsley Park, and thirty thousand people showed up. Prior to Free Press Summer Fest, most Houstonians had only a passing knowledge of music festivals. Austin City Limits had been a booming festival since 2002, and Houston had homegrown music showcases like the Westheimer Street Festival and BuzzFest and touring festivals like Lollapalooza, Lilith Fair and the Vans Warped Tour. The only thing close to FPSF for showcasing local bands was the Houston Press Music Awards. In its early years, FPSF was truly a civic event, making Houston a better place for live music. Suddenly, it felt like every city was getting its own music festival, and bands large and small, breaking or reuniting, felt compelled to hit these outdoor stages around the nation. The music festival scene became a big business, and booking larger bands became crucial to sustaining the ballooning event. In 2015, FPSF was sold to C3 Media, producers of Austin City Limits, Lollapalooza and Bonnaroo (C3 was later purchased by LiveNation). Responding to Houston's unpredictable summer weather, FPSF was moved to March and renamed In Bloom Music Festival.

AUGUST 9, 2O13

Funnel Tunnel

Today in 2013, Houston-based visual artist Patrick Renner completed his *Funnel Tunnel*, a 180-foot-long sculpture built from strips of painted, recycled wood woven onto a steel skeleton. The temporary public art piece was installed on the esplanade at the 1900 block of Montrose, right across from Art League Houston, which helped pay for it. The strips of old-growth pine were rescued from a doomed factory under demolition. The *Funnel Tunnel*, dedicated to the late Houston sculptor Lee Littlefield, weaved around trees, daring drivers to slow down and marvel at the sculpture. Locals and commuters alike applauded the art, and its success led to temporary art installations on Heights Boulevard and Downtown. Public Art Network of Americans for the Arts chose it as one of the

nation's best public art projects of 2013. After eighteen months, Renner dissembled the popular sculpture and gave away the hand-painted wood slats as souvenirs. The *Funnel Tunnel* then hit the road for an esplanade in New Orleans.

AUGUST 10, 1909

Hughes's Revolutionary Drill Bit

Hoping to strike it rich in the oil business, Howard Hughes Sr. moved to Beaumont and started a drilling company with Walter Sharp. After years of using poorly performing drill bits that wore out quickly digging through underground rock, Hughes (father of the future Hollywood producer and famed aviator) developed a successful drilling system that used two rotating steel cones to bore down into pockets of oil. After a few years of testing, Hughes received a patent for his innovative drill bit on this day in 1909. Hughes's revolutionary invention became the industry standard, and Hughes Tool Company would make his only son the richest man in the world.

AUGUST 11, 1956

Sam Houston Park

Seeking to create a city park, Mayor Sam Brashear appointed a park committee in 1899. On the western edge of town, on the south bank of Buffalo Bayou, the group found a twenty-acre site, renamed Sam Houston Park in 1903. For the first decades of the twentieth century, the existing site held the Houston Zoo, while the 1847 Kellum-Noble House was the headquarters for the Houston Parks Department. By 1954, when much of Houston was racing to the future, the historic structure faced demolition, but a group of preservationists formed the Harris County Heritage and Conservation Society (now the Heritage Society) to protect and renovate the home. From their efforts, that landmark was saved. On this day in 1956, City Council allowed additional historic buildings to be saved by relocating them to Sam Houston Park, where they would get the same treatment as the Kellum-Noble House. In the present day, there are nine

additional historic buildings that have been plucked from their original sites and saved there. Sam Houston Park is now a City of Houston Protected Landmark and a State of Texas Historical Site.

AUGUST 12, 1978

Voters Approved Metro

Today in 1978, voters approved the creation of the Metropolitan Transit Authority of Harris County (popularly known as Metro), which would be funded with a 1 percent sales tax increase. Metro took over bus service from the city-owned HouTran and would commence management of the four-hundred-bus fleet the next year.

AUGUST 13, 1856

Texas Rail Centered in Houston

Despite years of false starts, the Buffalo Bayou, Brazos and Colorado Railway began Texas's first rail service in August 1853 in nearby Harrisburg. Houston's first railroad, the Galveston and Red River Railway, began serving commercial interests in the Bayou City in 1856. Owing to the growing political muscle of Houston, the Texas legislature passed a bill making Houston, instead of Galveston, the center of the state's railroad system on this day in 1856. The rivalry between Houston and Galveston would continue to grow as both port cities sought commercial dominance.

AUGUST 14, 1837

Houston Voted

Every vote counts. This was especially true in the town of Houston's first public election. Today in 1837, James Holman was elected mayor of Houston, beating the colorful Francis Lubbock by one vote.

AUGUST 15, 1838

John Kirby Allen Dead

Today in 1838, Houston co-founder John Kirby Allen died after a short battle with yellow fever. In 1832, John left his home in upstate New York and joined his brother Augustus in Nacogdoches, where they worked as land speculators. During the Texas Revolution, the Allen brothers supplied the Texian Army at their own expense. Hoping to develop a town along Buffalo Bayou with access to Galveston Bay and the Gulf of Mexico, the brothers tried to buy land near Harrisburg but could not verify deed ownership. Following Sam Houston's victory at the Battle of San Jacinto, John and Augustus bought land where White Oak Bayou and Buffalo Bayou meet and declared their "Town of Houston" in an advertisement in the *Telegraph and Texas Register*; John Allen's candidacy for representative to the First Congress of the Republic of Texas was also announced in that edition. Allen's Landing and Allen Parkway were named in honor of the Allen brothers, and John Kirby Allen is one of many Houston pioneers buried at Founders Memorial Cemetery.

AUGUST 16, 1925

Sam Houston Statue Unveiled

Today in 1925, the bronze sculpture of General Sam Houston on horseback, set on a granite arch, was unveiled at the Sunken Gardens (now Mecom Fountain site). The gift from the Women's City Club of Houston had one vocal critic; Sam Houston's son hated it. Less than a year later, the iconic sculpture by Enrico Cerracchio was relocated to the Hermann Park entrance, where it sits in the present day, pointing to the San Jacinto Battlefield.

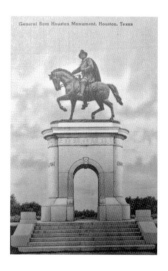

Sam Houston equestrian statue. *Author's collection.*

AUGUST 17, 1992

GOP in HOU

Today in 1992, the Republican National Convention convened in the Astrodome. Former Houston oilman and sitting U.S. president George H.W. Bush, always proud to show off his adopted hometown, welcomed delegates with a political platform that embraced socially conservative values. Nominee rival Pat Buchanan gave his famous anti–gay rights "Culture War" speech, and former president Ronald Reagan delivered his last major political speech at the convention.

AUGUST 18, 1983

Hurricane Alicia

On this day in 1983, Hurricane Alicia made landfall twenty-five miles southwest of Galveston. The Category 3 storm would eventually cause nearly $2 billion in damages, the record until Tropical Storm Allison in 2001. While mild on flooding, Alicia's gusts killed twenty-one people, downed countless trees and left thousands of Houstonians without electricity for days. The World Meteorological Organization retired the name "Alicia" in 1984.

AUGUST 19, 1965

The Beatles Played Houston

Today in 1965, the Beatles played two shows at Downtown's Sam Houston Coliseum on their second tour of the United States. The ten thousand fans who attended the afternoon show and the twelve thousand who attended the sold-out evening show paid $5 for a ticket to see the Fab Four. The Beatles were paid $85,000 for the two performances on this stop of the ten-city summer tour. Local radio station KILT broadcast the concerts, later widely available as a bootleg recording. The Beatles never played Houston again.

AUGUST 20, 1975

Mars Launch

Even though the Apollo program to the moon had ended, Americans' interest in space exploration was still high. Today in 1975, NASA launched the orbiter and lander Viking 1 from Cape Canaveral, Florida, on a crewless mission to Mars. On July 20, 1976, the nuclear-powered probe landed on the surface of the red planet, transmitting atmospheric and geological data and dramatic images. The solar-powered orbiter remained active until 1980, and the lander continued to transmit images until 1982. Along with its twin, Viking 2, Viking 1 sought proof of life on Mars, but following chemical experiments, no organic molecules were detected.

AUGUST 21, 1957

First Court of Appeals in Houston

Effective today in 1957, the Texas legislature moved the First Court of Appeals from Galveston to Houston, with Harris County providing facilities. An additional appeals court, the Fourteenth, would be created in 1967, and the two would be housed in various Downtown locations until moving into the lovingly restored 1910 Harris County Courthouse in 2011.

AUGUST 22, 1971

The De Luxe Show Opened

Art collectors John and Dominique de Menil were enthusiastic champions for the civil rights movement. The couple sought to help dismantle Jim Crow–era racial segregation in Houston through both public and private acts. One of their more public was hosting the contemporary art exhibition "The De Luxe Show," which opened at the predominantly black Fifth Ward's De Luxe Theater on this day in 1971. Following the exhibit, the de Menils kept the space open as the Black Arts Gallery until 1976. The De Luxe Theater was restored in 2015.

AUGUST 23, 1917

Camp Logan Mutiny
In the summer of 1917, the all-black Third Battalion, Twenty-Fourth U.S. Infantry, had been sent from Illinois to guard Camp Logan while it was under construction. Houston was deeply entrenched in racially segregated Jim Crow laws, and these soldiers were unaccustomed to the disrespect that greeted them, especially from Houston police. Today in 1917, after a long day of rumors of white mobs, a group of African American soldiers mutinied and marched into town looking to settle a score with some racist cops. Forty people were killed that night, and the next day, the governor declared martial law in Houston. Eventually, nineteen black soldiers were hanged following the nation's largest court-martial.

AUGUST 24, 2015

Arabic Immersion Magnet School Opened
In February 2014, Houston Independent School District proposed an Arabic language school to join its multiple Spanish immersion schools and Mandarin Chinese immersion school. In November, the HISD board voted unanimously to approve the school. On this day in 2015, the Arabic Immersion Magnet School opened, welcoming an inaugural class of eighty-eight kindergartners and forty-four pre-kindergartners. At the converted Heights-area elementary school, the teachers only speak Arabic to the students. Even though Houston has the country's fifth-largest Arab population, the first day of school was marred by a small group of anti-Muslim bigots, who picketed and shouted at the children.

AUGUST 25, 1917

Governor Will Hobby
Will Hobby, who moved to Houston as a child, worked at the *Houston Post* for ten years, making managing editor before the age of thirty. In 1907, he moved to the *Beaumont Enterprise* before entering politics in 1914, when he ran for lieutenant governor. In office, Hobby opposed a state ban on alcoholic

beverages and supported women's suffrage. On this day in 1917, in his second term in office, Governor Jim "Pa" Ferguson was impeached by the Texas legislature for misappropriating state money, making Hobby governor of the state of Texas. Will Hobby would win a full term as governor on his own but returned to newspaper publishing and acquired the *Houston Post* in 1939. His family would own Houston radio and television stations, as well as the *Houston Post*, until 1983. Hobby Airport was named in his honor.

AUGUST 26, 1836

Allen Brothers Secured Houston Site

In 1823, land developer and empresario Stephen F. Austin, who was famously known as the Father of Texas, received a land grant from the Mexican government to settle its northernmost state, Coahuila y Tejas, and led the first legal colonization of Mexican Texas with three hundred families, or the Old Three Hundred. Austin later subdivided and sold the lands in the Houston and Harrisburg areas. New York land speculators Augustus Allen and John Kirby Allen, who came to Texas to seek their fortune, saw potential in developing properties on the slow-moving Buffalo Bayou. With access to Galveston Bay and the Gulf of Mexico, the waterway could be used for commercial traffic to serve the newly born Republic of Texas. The brothers first attempted to buy land at Harrisburg but were unable to secure ownership deeds. Heading upstream, the Allen brothers bought the land at present-day Downtown Houston for $5,000 from Elizabeth Parrott.

AUGUST 27, 2017

Hurricane Harvey

Houstonians are old pros when it comes to hurricanes. They know how to prepare. They know when to flee. They know when to hunker down. In late August 2017, Category 4 storm Hurricane Harvey was headed for Houston, albeit at a slow pace, and Houstonians weren't encouraged to evacuate. The late-summer storm made landfall two hundred miles south of Houston on August 25, but that didn't seem to weaken it. A high-pressure ridge kept the storm on top of Houston. On this day in 2017, things got

worse. The rain started coming down harder and didn't let up, flooding all low-lying areas in the Bayou City. Twenty-four inches in twenty-four hours. The National Weather Service warned of "CATASTROPHIC LIFE THREATENING FLOODING." Houstonians were still recovering from the shocking Memorial Day flood in 2015 and the Tax Day flood in 2016. Some had decided to elevate their flooded homes, while most hoped the odds would be in their favor next time. They weren't. Neighborhoods inside the five-hundred-year flood plain were flooded too. Thirty-nine thousand people were forced to evacuate. Days later, when the rains slowly trickled off, fifty-one inches of rain had fallen in the Greater Houston area. Flood control levees on the west side did their jobs, holding back water from overtaking Buffalo Bayou (which stretches from the Katy Prairie through Houston's most expensive residential neighborhoods, to Downtown and to the Ship Channel). The U.S. Army Corps of Engineers, hoping to avoid catastrophic failure of the overtaxed earthen damns, cautiously opened the valves to relieve pressure. Neighborhoods closest to the levees were inundated. This second flood took weeks to recede, but Downtown was spared disaster.

During Harvey, social media came into its own, as thousands sought information on escape and shelter, while others cobbled together networks of volunteer rescuers with boats and big trucks. Countless more found ways to help online. At Downtown's George R. Brown Convention Center, the city opened its doors, and the line of volunteers was longer than the line of

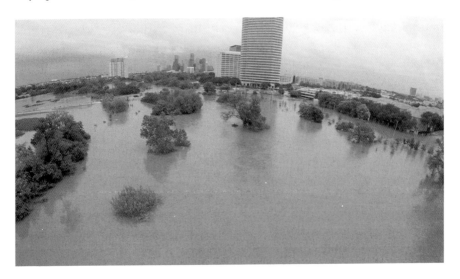

Hurricane Harvey flooding at Buffalo Bayou Park. *Courtesy of Ken Gray.*

evacuees. Movie stars, local celebrities and athletes raised money for victims. The Houston Astros, forced to play a few scheduled home games elsewhere, began wearing Houston Strong patches on their uniforms and dedicated the rest of their season to the city.

Physical and emotional trauma took months to heal, and many in Houston remained homeless. In the weeks and months that followed, neighbors helped neighbors remove sheetrock from flooded homes (to prevent mold from growing in wall cavities). Mayor Sylvester Turner fought the state and federal governments to get Federal Emergency Management Agency funds to those in the greatest need. City Council raised building elevations for new construction by two feet. Flood plain maps will doubtless be redrawn to include larger potential flood-prone areas. With a final price tag of $125 billion, Hurricane Harvey proved to be one of the costliest natural disasters the nation has ever seen.

AUGUST 28, 2010

Market Square Park Reborn

On a city block that was donated by Houston co-founders the Allen brothers and saw *four* City Halls from 1841 to 1939, Market Square Park is one of the most historic sites in Houston. From its proximity to the warehouses and trade along Commerce Street, the site doubled as a public market (giving it its name, too). In 1929, the City Market moved to a nearby site at Prairie Avenue and Smith Street, and in 1939, City Hall moved to its current location. A bus station was housed there until a fire left the block empty in 1960. Neighboring arts group DiverseWorks made a large impact when it collaborated with the Houston Parks Department and installed art from local artists, including a sculpture by James Surls. For the next twenty years, that part of Downtown remained desolate, especially at night. Eventually, city incentives revived the area. The Downtown Redevelopment Authority and Houston Downtown Management District worked with the City of Houston Parks and Recreation Department to develop a plan, manage redevelopment and operate the park following renovation. On this day in 2010, Market Square Park reopened, with a large lawn, a café, a dog run and a performance stage. With a nod to the original city charter, the park hosts open-air markets on the weekends.

AUGUST 29, 1856

Houston Academy Chartered

Today in 1856, the Houston Academy was chartered through the efforts of civic leaders William Marsh Rice, Peter W. Gray, Cornelius Ennis and Thomas House. Opened in 1858, the school held classes for 400 students separated by gender in a two-story brick building. Although the school closed during the Civil War, it reopened in 1866 with 205 students and a faculty of 6. In 1876, the school was incorporated into Houston's new public school system and renamed the Clopper Institute.

AUGUST 30, 1836

Houston Founded

On this day in 1836, Augustus and John Kirby Allen, brothers and hopeful land developers, placed an advertisement in—newspapers including the local *Telegraph and Texas Register* boasting of their new venture the "Town of Houston." In the months following the founding of the Republic of Texas, the duo, with financial help from Augustus's wife, Charlotte Allen, bought the site that would become Houston, shrewdly naming it for the hero of San Jacinto and hoping to secure it as the new nation's capital. Their ad, which was full of exaggerations, if not downright lies, read:

> *SITUATED at the head of navigation, on the west bank of Buffalo Bayou, is now for the first time brought to public notice because, until now, the proprietors were not ready to offer it to the public, with the advantages of capital and improvements.*
>
> *The town of Houston is located at a point on the river which must ever command the trade of the largest and richest portions of Texas. By reference to the map, it will be seen that the trade of San Jacinto, Spring Creek, New Kentucky and the Brazos, above and below Fort Bend, must necessarily come to this place, and will at this time warrant the employment of at least ONE MILLION DOLLARS of capital, and when the rich lands of this country shall be settled, a trade will flow to it, making it, beyond all doubt, the great interior commercial emporium of Texas.*
>
> *The town of Houston is distant 15 miles from the Brazos River, 30 miles, a little North of East, from San Felipe, 60 miles from Washington,*

40 miles Lake Creek, 30 miles South West from New Kentucky, and 15 miles by water and 8 or 10 miles by land above Harrisburg. Tide water runs to this place and the lowest depth of water is about six feet. Vessels from New Orleans or New York can sail without obstacle to this place, and steamboats of the largest class can run down to Galveston in 8 or 10 hours, in all seasons of the year. It is but a few hours sail down the bay, where one may take excursions of pleasure and enjoy the luxuries of fish, foul, oysters and sea bathing. Galveston harbor being the only one in which vessels drawing a large draft of water can navigate, must necessarily render the Island the great naval and commercial depot of the country.

The town of Houston must be the place where arms, ammunitions and provisions for the government will be stored, because, situated in the very heart of the country, it combines security and means of easy distribution, and a national armory will no doubt very soon be established at this point.

There is no place in Texas more healthy, having an abundance of excellent spring water, and enjoying the sea breeze in all its freshness. No place in Texas possesses so many advantages for building, having Pine, Ash, Cedar and Oak in inexhaustible quantities; also the tall and beautiful Magnolia grows in abundance. In the vicinity are fine quarries of stone.

Nature appears to have designated this place for the future seat of Government. It is handsome and beautifully elevated, salubrious and well watered, and now in the very heart or centre of population, and will be so for a length of time to come. It combines two important advantages: a communication with the coast and foreign countries, and with different portions of the Republic. As the country shall improve, rail roads will become in use, and will be extended from this point to the Brazos, and up the same, also from this up to the head waters of San Jacinto, embracing that rich country, and in a few years the whole trade of the upper Brazos will make its way into Galveston Bay through this channel.

Preparations are now making to erect a water Saw Mill, and a large Public House for accommodation, will soon be opened. Steamboats now run in this river, and will in short time commence running regularly to the Island.

The proprietors offer lots for sale on moderate terms to those who desire to improve them, and invite the public to examine for themselves.

A.C. Allen, for A.C. & J.K. Allen

AUGUST 31, 1968

First Multi-Organ Transplant

Dr. Michael DeBakey was a medical pioneer the likes of whom none had ever seen. Following World War II, the innovative surgeon moved to Houston, where he was a central figure in developing aneurism repair, coronary bypass techniques, heart transplantation and the artificial heart. On this day in 1968, DeBakey supervised five teams of surgeons in the first multi-organ transplant, which began within eight hours of the donor's death and involved more than sixty surgeons, nurses and staff. From that single donor, the team removed the heart, the lobe of one lung and the kidneys, transplanting them into four patients. In 1969, Michael DeBakey, considered the father of modern cardiovascular surgery, received the Presidential Medal of Freedom. Following his death in 2008 at age ninety-nine, DeBakey was the first Houstonian to lay in repose at City Hall.

SEPTEMBER

SEPTEMBER 1, 2005

Astrodome Opened to Hurricane Katrina Evacuees

Houstonians, for better or worse, know all about hurricanes. So much of Houston's history is intertwined with the deadly late-summer storms— even when the hurricane misses Houston altogether. This was the case with Hurricane Katrina. Sitting at sea level on the Gulf Coast, New Orleans is constantly protected from flooding by man-made levees. When Hurricane Katrina slammed into New Orleans, the storm surge caused the barriers to fail, allowing floodwaters to take over the city's streets and structures. Even though the storm's damage was the costliest U.S. hurricane to date, the larger story was in the countless victims driven from their homes and in the local and federal government that was slow to respond to those in need. On this day in 2005, Harris County opened its vacant Astrodome as a temporary shelter to evacuees from neighboring Louisiana who had fled their flood-damaged homes days earlier. The image of the Dome floor holding eighteen thousand Katrina victims was shocking in its sheer scope and would be the lasting image from those weeks, forever burned into Houston's collective memory. When the Astrodome could take no more evacuees, the county opened nearby Reliant Arena, and the City of Houston opened the George R. Brown Convention Center. Over the following weeks, Houston welcomed nearly a quarter million people from Louisiana, Alabama and Mississippi, many making Houston their permanent home. It was one of Houston's finest hours.

SEPTEMBER 2, 1946

The Fifth Beatle

Today in 1946, songwriter and keyboardist Billy Preston was born in Houston. As an organist for Little Richard's band, Preston met the Beatles in 1962. Throughout the 1960s, Preston played with Sam Cooke and Ray Charles. In 1969, while in London, Billy Preston was asked by George Harrison to join the Beatles in the studio, recording "Get Back." Preston's keyboards lit up the song, and his contribution led to co-songwriting credits on the single, where it read "The Beatles with Billy Preston." His collaboration led many to dub him the "Fifth Beatle." In the 1970s, Preston had both the instrumental hit "Outa-Space" and the vocal hits "Will It Go Round in Circles" and "Nothing from Nothing"—an extremely rare feat. With Janis Ian, he was the first musical guest on *Saturday Night Live*. Preston died in 2006.

SEPTEMBER 3, 1991

Left Ventricular Assist Device

On this day in 1991, Dr. Bud Frazier implanted the first successful battery-powered left ventricular assist device (LVAD) in a thirty-three-year-old man waiting for a heart transplant at St. Luke's Hospital's Texas Heart Institute. The patient's health improved immediately, and within a few months, he was allowed overnight stays outside the hospital. Since then, Dr. Frazier's device would become the most widely used LVAD worldwide. Today, the heart pioneer is working on a continuous-flow device that circulates blood without the need for a heart at all.

SEPTEMBER 4, 2000

Hottest Day

Today in 2000, Houston had its hottest day on record at 109 degrees. No Houstonian was surprised because it also happened to be native Houstonian and force of nature Beyoncé Knowles's birthday (1981).

SEPTEMBER 5, 1836

Houston Elected President

Just days after the founding of his namesake town, General Sam Houston was elected president of the Republic of Texas. Also on this day in 1836, Republic of Texas voters approved seeking annexation by the United States. When the Republic of Texas Congress convened months later in nearby Columbia, members chose Houston as the location for the capital (albeit temporarily).

SEPTEMBER 6, 1988

Home Run Spectacular Dimmed

Today in 1988, a ninth-inning home run by Glenn Davis ignited the famous Astrodome Home Run Spectacular one last time. The huge light display would be removed so that Houston Oilers owner Bud Adams could get his demand of an additional fifteen thousand seats. Fans of the low-tech-but-charming light show would be surprised in 2000, when the animated display was resurrected on the jumbo TV screen in the new Downtown ballpark. The tradition lives, with bulls still snorting and fireworks still exploding every time an Astro hits a home run.

SEPTEMBER 7, 1943

Gulf Hotel Fire Took Fifty-Five

On this day in 1943, fifty-five people perished in a fire at the Gulf Hotel—the worst loss of life from a fire in the history of Houston. The small Downtown hotel was located on the northwest corner of Louisiana and Preston Streets, occupying the upper two floors of a three-story brick building. Shortly after midnight, the desk clerk attempted to extinguish a smoldering mattress, probably lit from a stray cigarette. Even though the fire department was only a few blocks away, many escaped on the fire escape or by jumping before fire hoses could reach them. Among the fifty-five fatalities, twenty-one unidentified victims were buried at the South Park Cemetery. The disaster led directly to the City of Houston establishing a fire code.

SEPTEMBER 8, 2002

Houston Texans

By the time the once-beloved Oilers ended their final season in Houston, their football fans had already checked out. Even though they had a decent run in the early 1990s and won the division title in 1991, owner Bud Adams had his eyes on the exit. After 1987's expensive renovation of the Astrodome, political leaders and voters weren't open to putting more money into the landmark so soon. Adams moved the team to Tennessee, and Houston was without a pro football team for the first time in decades. In 1999, the NFL awarded Houston an expansion team, and the Harris County–Houston Sports Authority built the brand-new $352 million Reliant Stadium right next to the Astrodome. Today in 2002, the Houston Texans played their first regular season game, beating the Dallas Cowboys. Sadly, the Texans have only made it to the playoffs a few times.

SEPTEMBER 9, 1968

Oilers in the Astrodome

Houston Oilers owner Bud Adams and Astros owner (and Astrodome landlord) Roy Hofheinz were not pals. Even though they were both owners of brand-new sports franchises and charter members of the Houston Sports Association, the two outsized personalities had a public feud that kept Adams's American Football League (later AFC) team from playing in the biggest room in town. Founded in 1960, the Oilers played their home games in Rice Stadium. When the Astrodome opened in 1965, the Astros owner showed the world that professional sports could work indoors. In fact, a segment of the Dome's field-level seating could be rotated to allow for close viewing along baseball's diamond shape or football's rectangular shape. Bud Adams's stated reason for staying away from the Astrodome was that the rent was too high, but he eventually relented, and on this day in 1968, the Houston Oilers played their first regular season game in the Astrodome, losing to Kansas City.

SEPTEMBER 10, 2013

Greenway Plaza Sold

Kenneth Schnitzer built the 127-acre mixed-use development Greenway Plaza over many years beginning in 1967. Sitting atop multiple levels of underground parking are traditional office buildings, a hotel and adjacent residential towers. A large food court held a three-screen movie theater until 2007. The sports and entertainment venue the Summit, facing the Southwest Freeway, was Greenway Plaza's most visible and visited destination. On this day in 2013, the ten-building Greenway Plaza was sold by Crescent Real Estate Holdings to Atlanta-based Cousins Properties for $950 million.

SEPTEMBER 11, 1961

Hurricane Carla Struck Houston

Today in 1961, Category 4 Hurricane Carla made landfall near Port Lavaca, with winds as high as 110 miles per hour. Due to emerging satellite and radar technologies on broadcast TV, half a million people were able to evacuate, keeping the death toll to forty-six. Future network television anchor Dan Rather, reporting for a local news station, placed himself in the path of the storm and gained national fame for the stunt (which is still performed by ambitious reporters). The National Weather Service would rank Hurricane Carla as the ninth-most intense hurricane to affect the United States. Even though Carla was the last Category 4 to hit Texas, "smaller" hurricanes would later prove to be far deadlier.

SEPTEMBER 12, 1962

JFK at Rice

"We choose to go to the moon in this decade and do the other things, not because they are easy, but because they are hard, because that goal will serve to organize and measure the best of our energies and skills, because that challenge is one that we are willing to accept, one we are unwilling to postpone, and one which we intend to win." When President John Kennedy spoke these words on this day in 1962 at Rice Stadium, he rallied the nation to increase

President Kennedy speaking at Rice Stadium. *Courtesy of NASA.*

its commitment to winning the so-called Space Race against the Soviet Union, making NASA a "high national priority." Kennedy had been pushing this ambitious agenda since a 1961 speech to Congress and was in Houston to tour the new Manned Spacecraft Center in Clear Lake. Houston was on the verge of becoming Space City; but then again, Houstonians have always been a forward-looking community that embraced invention and innovation. Humans would land on the moon in 1969. That hot September day in 1962, Kennedy closed his inspiring remarks with, "As we set sail, we ask God's blessing on the most hazardous and dangerous and greatest adventure on which man has ever embarked."

SEPTEMBER 13, 2OO8

Hurricane Ike

No two hurricanes are the same; Houstonians forget this all the time. In the fall of 2005, with the Gulf Coast still reeling from Hurricane Katrina's wrath, no one was taking storms for granted. Weeks after Katrina clobbered New Orleans and made tens of thousands homeless, Hurricane Rita looked to be a bigger and badder sequel. Images of Katrina's biblical-level flooding were still fresh in the minds of all Americans, but they were especially vivid to Houston natives and newcomers alike. Before Rita made landfall near the Texas/Louisiana border, most of Houston freaked out and fled. Gridlock choked all outbound freeways heading north and west, creating the largest traffic jam in the nation. Thankfully, Rita spared Houston. Cut to 2008, when another slow-moving but strong storm was heading toward the Bayou City. On this day in 2008, Hurricane Ike made landfall and struck Houston hard, but this time many Houstonians, remembering the traffic nightmare in 2005, hunkered down. The mayor and the county judge calmly reminded Houstonians that the city is fifty feet above sea level and fifty miles from the coast. Some fled, but no mandatory evacuation was ordered. The storm surge topped Galveston's seawall land barrier and flooded everyone along

Galveston Bay. In Houston, Hurricane Ike made its mark not with rain but with winds. Millions lost electrical service from downed power lines, countless high-rise windows were blown out and Mayor Bill White instituted a curfew. Legendary restaurant Brennan's suffered a catastrophic fire but rebuilt years later better than ever. Months following Ike, blue tarps provided by the Federal Emergency Management Agency covered damaged roofs all over town. With damage estimates topping $29.5 billion, Hurricane Ike was the second-costliest hurricane to hit the United States at that time.

SEPTEMBER 14, 1961

Sharpstown Center

Today in 1961, Sharpstown Center, Houston's third mall—and the first enclosed with air conditioning—opened its doors. Located in Frank Sharp's southwest Houston development, Sharpstown was on the edge of Houston until the Southwest Freeway bisected the neighborhood (on land shrewdly donated by Sharp). Anchored by department stores Montgomery Ward, Foley's and Battelstein's, Sharpstown Center also had a variety of specialty shops, a cafeteria and a grocery store. Sharpstown Center grew throughout the 1970s and in 1981 added a food court with the popular teen hangout Goodtime Charley's. After JCPenney and Montgomery Ward left, Foley's was unable to keep up the traffic, and in 2001, the mall entered foreclosure proceedings. In late 2009, Sharpstown Center (sometimes called Sharpstown Mall) was bought and rebranded as PlazAmericas, with a Latino flavor reflecting the area's change in demographics.

SEPTEMBER 15, 1959

Poe Elementary Explosion

Today in 1959, a deranged parent detonated a homemade bomb at Poe Elementary School, killing himself, his son, two other children, a teacher and a custodian. In the blast, nineteen were critically injured. Seeking to enroll his seven-year-old son Dusty at the elementary school, Paul Orgeron aroused suspicion when he couldn't answer questions about his son's previous school attendance. Later, it was discovered Orgeron had a police record, including

three terms in prison. Second-grade teacher Jennie Kolter and custodian James Montgomery, who both perished that Tuesday morning, would later have elementary schools named in their honor.

SEPTEMBER 16, 1963

Houston Baptist College Opened

In 1952, the Union Baptist Association began studying the possibility of founding a Baptist college in Houston, and by 1960, the Baptist General Convention of Texas had created the Houston Baptist College. Early benefactors included land developer Frank Sharp, who offered to sell the Union Baptist Association land in southwest Houston, and the Board of Governors of Rice University, who agreed to loan money to the new private institution. On this day in 1963, Houston Baptist College opened, with a freshman class of 193 students and 30 faculty. In 1973, Houston Baptist College renamed itself Houston Baptist University. Presently, HBU has more than 3,000 combined undergraduate and graduate students on a campus that has grown to one hundred acres, with direct access to the Southwest Freeway.

SEPTEMBER 17, 1998

John Lawrence Arrested

On this day in 1998, a Harris County sheriff, responding to a fake burglary call, arrested Pasadena resident John Lawrence for "deviant sexual intercourse with another individual of the same sex," which was against the law in the state of Texas. In 2002, the U.S. Supreme Court ruled that the anti-gay law was unconstitutional.

SEPTEMBER 18, 1899

Carnegie Library Donation

At the end of the nineteenth century, a group of five Houston women's clubs, seeing the need for improved civic library facilities, requested assistance from

industrialist Andrew Carnegie, who had been building libraries all over the United States. On this day in 1899, Carnegie donated $50,000 for a public library. In 1904, the Houston Lyceum and Carnegie Library opened on the corner of Travis and McKinney and served the community until 1926.

SEPTEMBER 19, 2012

Space Shuttle *Endeavour* Visited

In 2011, after thirty years of spaceflight and more than 130 missions, NASA announced the new homes for the soon-to-be retired space shuttle fleet. Shuttle *Discovery* would be retired to the Smithsonian's National Air and Space Museum, Shuttle *Endeavour* would go to the California Science Center in Los Angeles and Shuttle *Atlantis* would remain at the Kennedy Space Center in Florida. But what about the fourth shuttle? Shuttle *Enterprise* was the first orbiter built and the one that got its name from *Star Trek* fans demanding it be named after the fictional space ship. Sure, it never actually went into orbit, but it's still a space shuttle. In a humiliating slap in Houston's face, NASA chose to send the *Enterprise* to…*New York City*. The shuttle was eventually housed on top of the *Intrepid* aircraft carrier on the Hudson River, because why not? Outraged Houstonians wondered if NASA forgot about Mission Control at the Johnson Space Center, but they were powerless to change NASA's mind and get their own retired shuttle. On its final journey, the Shuttle *Endeavour* left NASA's Kennedy Space Center on top of a 747 heading for Los Angeles. On this day in 2012, the Shuttle *Endeavour* flew a lap around Houston, stayed the night at Ellington Field and reminded Houston of its snub. Oh, and NASA gave Houston a fake shuttle to sit on a retired 747.

Space Shuttle *Endeavour* at Ellington Field. *Courtesy of Renée Miller.*

SEPTEMBER 20, 1973

The Battle of the Sexes

One thing that the Astrodome is good with is spectacles. In its fifty-plus years as Houston's beloved signature landmark, the air-conditioned sports and entertainment stadium has hosted epic championship matchups in baseball, football, basketball and boxing. It has also seen its share of unforgettable live performances, from Elvis to Willie to the Rolling Stones. And let's not forget the wildly in-between big-ticket events like the monster truck rallies, bullfights, Wrestlemania and the actual circus. Combining sports, theater and the downright bizarre was the so-called Battle of the Sexes. Former men's tennis champ Bobby Riggs, hoping to get himself back in the spotlight, challenged twenty-nine-year-old Billie Jean King, who was ranked the number-two women's tennis player, to a televised match in the Astrodome. On this day in 1973, after weeks of trash-talking and showboating, Riggs lost to King. The victory helped King and other women achieve greater parity in prize money and equality in sports and moved the women's rights movement forward a few steps.

SEPTEMBER 21, 1946

University of Houston Football Game Kicked Off

University of Houston Cougar mascot. *Author's collection.*

Today in 1946, the University of Houston Cougars lost to Southwestern Louisiana Institute in their debut football game. Eleven thousand people cheered Cougar quarterback Charlie Manichia, who scored the first UH touchdown, giving the hometown team an early lead. The final score at Houston Public School Stadium was 13–7. (HISD School Board named the venue Jeppeson Stadium in 1958, and UH renamed it Robertson Stadium after buying it from HISD in 1970.) Although not in the same conference, UH joined Rice as a second local team to root for. The University of Houston Cougars would go on to win eleven conference championships, have several players elected to the College Football Hall of Fame and see quarterback Andre Ware win a Heisman Trophy in 1989.

SEPTEMBER 22, 1975

Loop 610 Was Completed

Originally conceived as a "Defense Loop" to allow troops to defend the Houston Ship Channel, Loop 610 was approved by voters in a 1941 bond election. On this day in 1975, Houston's first freeway loop was completed. Since then, Houston sprawl has been encouraged by subsequent loops— Beltway 8 and under-construction and controversial Grand Parkway. Loop 610 remains the informal boundary for inner Houston. Countless Houstonians self-identify proudly as "Inside the Loop" or "Outside the Loop." Despite Houston's growing geographic homogeneity, Inner Loop snobbery persists.

The City of Houston Planning Department had proposed an "outer belt" as far back as 1952. By 1960, Harris County took over the planning of what then became a freeway loop outside Loop 610. Construction began in 1970 on various segments, and during its decades-long construction, some portions were designated as toll roads, a new concept for most Houstonians. Houston's second loop would connect Bush Intercontinental Airport, Humble, Channelview, the Ship Channel, Deer Park, Pasadena, Pearland, Missouri City, Sugar Land, Alief, Westchase, Spring Branch, Jersey Village, Cy-Fair and Greenspoint. In 2011, construction on the eighty-eight-mile outer loop Beltway 8 finished (is freeway construction ever really finished?).

SEPTEMBER 23, 1900

William Rice Murdered

In 1891, Massachusetts-born businessman William Marsh Rice, who had made a fortune in Houston, planned to open an institute of higher learning as a gift to the city. Rice moved to Houston in 1837 and amassed his wealth importing and exporting and co-owned several local railroads, ultimately becoming one of the richest Texans of his day. Toward the end of the century, he moved to New York City, while maintaining his interests and investments in Houston. On this day in 1900, the eighty-four-year-old Rice was murdered in his sleep by his valet, Charlie Jones, in cahoots with the crooked lawyer Albert Patrick. With a forged will, the two plotted to claim his vast estate. Houston lawyer Captain James Baker insisted on an autopsy, which showed Rice had been the subject of foul play, thus saving the trust for Rice Institute. The William M. Rice Institute for the

Advancement of Literature, Science and Art opened in 1912—twelve years to the day after his death.

SEPTEMBER 24, 1923

South Texas College of Law Opened
Today in 1923, South Texas School of Law opened as a night school, with seven part-time instructors and a class of thirty-four students. Classes were held in a room in the basement of the YMCA, but by 1945, enrollment had surpassed that of the University of Texas School of Law. Today, after thwarted attempts to merge with Texas A&M and a naming fight with University of Houston's College of Law, the private, accredited institution is known as South Texas College of Law Houston.

SEPTEMBER 25, 1937

Houston Endowment Founded
On this day in 1937, Jesse Jones and Mary Gibbs Jones established the Houston Endowment to help create and develop institutions and organizations that would nurture Houstonians and encourage the city of Houston's growth. Throughout the 1940s, Jesse Jones (famously known as "Mr. Houston") transferred his vast financial portfolio of buildings and businesses to the foundation. As the Houston Endowment's annual donations increased, so did the size of the donations, most notably to the University of Houston and Rice University (the first women's college at Rice was named for Mary Gibbs Jones). The foundation also sought smaller targets for its generosity—funding health and human service organizations and college and university scholarship programs, especially for minority students. The endowment's commitment to the arts covered both established and emerging arts organizations and culminated in Jones's dream for a world-class center for the performing arts. In 1962, the foundation donated the land for the Alley Theatre and built and then donated a new Downtown venue to the city. The Jesse H. Jones Center for the Performing Arts opened in 1966, signaling the area's transformation into a thriving theater district. Today, it is nearly impossible to find an arts organization in Houston without the support of Houston Endowment.

SEPTEMBER 26, 1927

The Toonerville Trolley Ended Service

William Wright Baldwin's South End Land Company developed the city of Bellaire in 1910. His new site was so far away from Houston's city limits that he knew access would be an issue. For the new community, he built Bellaire Boulevard and an electric streetcar line to connect to Main Street. Dubbed the "Toonerville Trolley," this line ran from 1912 until this day in 1927. Presently, a retired trolley car sits forlornly on the Bellaire Boulevard esplanade at South Rice Avenue.

SEPTEMBER 27, 1987

The George R. Brown Convention Center Opened

Named for the native Houstonian, entrepreneur and philanthropist, the George R. Brown Convention Center opened today in 1987. At the time, the 1.15-million-square-foot center (with three large exhibition halls) sat up against U.S. 59 and was surrounded by mostly abandoned land on the east side of Downtown. Things wouldn't start to improve until the long-delayed convention center hotel the Hilton Americas–Houston and the Toyota Center opened across the street in 2003. During construction of its neighbors, the GRB grew from 1.15 million square feet to 1.8 million square. In 2008, the beautiful, game-changing twelve-acre park Discovery Green opened at the GRB's front door (on blocks of former surface parking lots). The George R. Brown would grow once more in 2014 for a new garage, Avenida Plaza, a pedestrian-oriented outdoor space and four new street-level restaurants—just in time for Super Bowl LI in 2017.

SEPTEMBER 28, 1940

The New Municipal Airport Terminal Was Dedicated

In 1927, W.T. Carter Jr. opened a landing strip for air deliveries on 193 acres in south Houston, and in 1937, the City of Houston bought the site, renaming it Houston Municipal Airport. On this day in 1940, a modern Art Deco passenger terminal, control tower and hangar, designed by Joseph Finger,

Municipal Airport. *Author's collection.*

opened. At first, the young airport was only served by Braniff Airways and Eastern Airlines. Later renamed, Houston International Airport welcomed international flights from Pan Am, Air France and KLM, and in 1967, it was again renamed as William P. Hobby Airport to honor the former governor and Houston businessman. When Houston Intercontinental Airport opened in 1969, Hobby discontinued commercial airline service until Southwest Airlines made Houston a major hub. The original airport building was abandoned for a modern terminal but later restored and made the home of the 1940 Air Terminal Museum.

SEPTEMBER 29, 1923

Houston Oilers Coach Bum Phillips Was Born

Today in 1923, Houston Oilers head coach Bum Phillips was born down the road from Houston in Orange, Texas. The colorful and beloved cowboy hat–wearing Phillips joined the Oilers as defensive coordinator in 1974, the next year was made head coach and in 1977 added the role of general manager. Even though the Oilers went to the playoffs in three consecutive seasons, twice losing to Pittsburgh, owner Bud Adams felt the Oilers' most

recent loss had been caused by Bum Phillips's disdain for the offensive coordinator position, which had been unfilled on his staff since 1977. Philips was famously fired in 1980 three days after the team lost to the Oakland Raiders in the American Conference wildcard playoff matchup. After leaving the Oilers, Phillips was head coach for the New Orleans Saints from 1981 to 1985. Later, in his typical folksy stye, Bum said, "There's two kinds of coaches, them that's fired and them that's gonna be fired."

SEPTEMBER 30, 1950

Rice Stadium Opened

In the days before the Astros and the Oilers, Houstonians loved to see the Rice Owls play football in their track-and-field stadium. Owing to the sport's growing popularity, Houston entrepreneur and philanthropist George Brown (of construction company Brown & Root) designed and built a new seventy-thousand-seat football stadium on the campus of Rice Institute. The speedy eleven-month schedule meant the venue would be ready for the school's home opener, on this day in 1950.

OCTOBER

OCTOBER 1, 1837

The Texas General Land Office Opened in Houston

The First Congress of the Republic of Texas established the General Land Office on December 22, 1836, to manage the public domain of the new nation. The office was empowered to collect and keep records, provide maps and surveys and issue titles. In addition to the office encouraging settlement of public lands via land grants, scrip certificates were redeemable for land and used to raise cash to finance the Texas Revolution and the nation's expenses. On this day in 1837, John Borden, its first commissioner, opened the General Land Office in Houston. In 1839, he moved the GLO to Austin. Today, the Texas General Land Office is focused on maintaining the revenue sources for the Permanent School Fund.

OCTOBER 2, 1966

Jones Hall Opened

Jesse Jones's Houston Endowment built a performing arts venue where the City Auditorium once stood. On this day in 1966, the endowment handed over the keys to the Jesse H. Jones Hall for the Performing Arts to the City of

Houston. The hall became the home for the Houston Symphony Orchestra, the Houston Grand Opera Association and the Houston Ballet Foundation. Even though the opera and ballet eventually moved into the nearby Wortham Center, Jones Hall has remained the center of the Downtown Theater District. An impossibly large multi-block subterranean garage connected all of the facilities, the Alley Theatre and the Albert Thomas Convention Center and stretched all the way to City Hall.

OCTOBER 3, 2015

Buffalo Bayou Park Grand (Re)opening

In the 1970s and '80s, the public park that flanked the banks of Buffalo Bayou from Shepherd to Downtown Houston received little attention from the city. Over the years, a few modest running trails were installed, but most Houstonians avoided what was referred to simply as "Allen Parkway," after the street running south of the slow-moving waterway. In 1986, the nonprofit Buffalo Bayou Partnership was founded to develop a master plan and raise money to reinvent the shabby park. Minor improvements came in the late 1980s and early 1990s. The Sabine Promenade and Sesquicentennial Park were followed by the Houston Police Officers' Memorial on the north bank along Memorial Drive. In 1998, a portion of the south bank near the Sabine Street Bridge was renamed in honor of Councilwoman Eleanor Tinsley, and in 2008, the Lee and Joe Jamail Skatepark opened, to the cheers of skateboarders old and young. Beginning in 2012, Buffalo Bayou Park's largest capital campaign kicked off, eventually raising over $58 million to implement its master plan, with new facilities and amenities like the Lost Lake Visitors Center, the Dunlavy, Johnny Steele Dog Park, new footpaths with lighting, water features, pedestrian bridges and aggressive re-landscaping with native-only plants. On this day in 2015, Buffalo Bayou Park had its grand (re)opening. The tremendous interest in the new signature public park led the City of Houston to redesign the lanes of Allen Parkway, with improved pedestrian access and increased parking, and to develop an ambitious master plan connecting all of Houston's natural waterways with pedestrian and bike paths.

OCTOBER 4, 1887

Capitol Hotel Sold to Rice

Today in 1887, Houston industrialist William Marsh Rice bought the Capitol Hotel. Following Rice's murder, Rice Institute would own the property and rename it in his honor. Jesse Jones would later tear down the five-story structure and build the landmark seventeen-story Rice Hotel on the site.

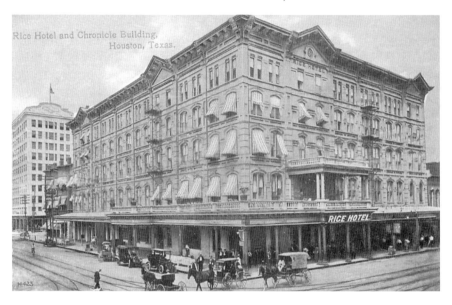

Second Capitol Hotel after being renamed the Rice Hotel. *Author's collection.*

OCTOBER 5, 1974

Texas Renaissance Festival Opened

Today in 1974, the Texas Renaissance Festival opened its first season, with three stages on fifteen acres. Founded by George Coulam, RenFest (as it is now lovingly referred to) began as a small outdoor fair, with handmade crafts, oversized turkey legs and jousting, with all dressed in sixteenth-century costumes and set in the woods near Plantersville, northwest of Houston. In recent years, the Renaissance Festival has increased its permanent home to sixty acres, with twenty-five stages and four hundred shops. As if the

Renaissance theme and cosplay weren't enough, the multi-weekend fall event expanded to specific sub-theme weekends like Oktoberfest, Pirate Adventure, Roman Bacchanal and Barbarian Invasion. The overnight camping is quite a party—or so we hear.

OCTOBER 6, 1972

First Same-Sex Marriage in Texas

The day before Antonio Molina and William "Billie" Ert got married at Houston's Harmony Wedding Chapel, they went for a marriage license. Apparently, the Wharton County clerk didn't know both were men. At the time, other same-sex couples had tried unsuccessfully to wed, but societal standards were not yet there, and laws prevented it. On this day in 1972, the Wharton County clerk refused to record their license. The couple sued the county for recognition. The State of Texas reacted to Molina and Ert's union, and lawmakers quickly closed the loophole, changing "persons" to "a man and a woman."

OCTOBER 7, 1997

"Everybody's Rockin' Down on Telephone Road"

Proving that rehab and a stay in prison were behind him, outspoken country rocker Steve Earle released his seventh album, *El Corazón*, on this day in 1997. Whether infusing songs with rock, country or bluegrass, Earle was never afraid to address tough social issues or complicated emotions. His rollicking, up-tempo "Telephone Road" (with backing vocals from gospel group The Fairfield Four) recalled a time for him when Houston was a blue-collar boomtown for young men who moved there to find work. Earle closed the album with "Ft. Worth Blues," a tribute to his mentor and occasional Houston singer-songwriter, the late great Townes Van Zandt.

OCTOBER 8, 1915

First Southwest Conference Football Game

Today in 1915, Baylor beat Rice Institute, 26–0, in the first Southwest Conference football matchup. That season, the Southwest Intercollegiate Athletic Conference also included the University of Oklahoma, Texas A&M, University of Arkansas, University of Texas, Southwestern and Oklahoma State. The SWC was founded the prior year at the Rice Hotel in Houston and would became a much-beloved family of rivals in Texas and adjoining states. Over time, more schools were added and some left. In 1996, the Southwest Conference would fold after UT, A&M, Texas Tech and Baylor split for a better offer from the Big 8, then renamed Big 12.

Rice Owl mascot. *Author's collection.*

OCTOBER 9, 1996

Rice Scientists Won the Nobel Prize

In 1985, Rice University scientists Robert Curl and Richard Smalley, with the University of Sussex's Harold Kroto, discovered new forms of the element carbon, where the sixty atoms are arranged in closed shells. They named the forms of carbon atoms bound in the shape of a ball "buckminsterfullerenes" (or buckyballs) for architect R. Buckminster Fuller and his geodesic dome. Their discovery was the third molecular form of carbon, behind diamonds and graphite. On this day in 1996, the Royal Swedish Academy of Sciences awarded the Nobel Prize in Chemistry jointly to the trio "for their discovery of fullerenes." Their work led to advances in the field of nanoscience, the development of carbon nanotubes and the super-strong, transparent material graphene.

OCTOBER 10, 1947

Alley Theatre Kick-off
In 1946, Houston high school drama teacher Nina Vance took a leave of absence to direct plays at the Jewish Community Center. There, she realized that Houston needed a permanent repertory theater company. On this day, with the encouragement of her peers, Vance mailed 214 penny postcards soliciting donors and volunteers for her new theater. At their first meeting, over one hundred people joined Vance at 3614 Main. The modest dance studio was accessed through an alley, thus giving the new theater company its name: the Alley Theatre.

OCTOBER 11, 1915

Texas Women's Fair
Today in 1915, Houston hosted the Texas Women's Fair, featuring exhibitions, demonstrations and a "better-baby show." The multiday event drew on the growing interest in women's suffrage, and other cities began fairs of their own.

OCTOBER 12, 1912

Rice Institute Opened
In 1907, the trustees of the Rice Institute hired astronomer and mathematician Edgar Odell Lovett to be their first president. On this day in 1912, Rice Institute opened with seventy-seven students and a dozen faculty members, and Lovett was inaugurated. At the first commencement in 1916, Rice awarded thirty-five bachelor's degrees and one master's degree.

OCTOBER 13, 2010

Historic Preservation Ordinance Strengthened
Today in 2010, Houston City Council fulfilled Mayor Annise Parker's pledge to kill the mostly worthless ninety-day waiting period for demolitions and inappropriate physical changes to properties in historic districts.

Previously, if an existing structure was designated a Landmark or Protected Landmark, then it could not be altered or demolished without a Certificate of Appropriateness from the Houston Archaeological and Historic Commission, which made recommendations to Houston City Council. However, if permission was *not* granted, then the changes could proceed following ninety days. Also, new amendments to Houston's 1995 Historic Preservation Ordinance (HPO) included tougher rules for creation of historic districts—now 67 percent of property owners within a proposed district must approve of the application. A Certificate of Appropriateness from the Houston Archaeological and Historic Commission would still be required before City Council would review the site. Additionally, existing historic districts would be given the opportunity for "reconsideration" if at least 10 percent of property owners within the district petitioned for its repeal, and 51 percent of property owners were required to remove historic district status.

And in this amendment, the City of Houston designated the Old Sixth Ward a protected historic district. Originally known as the Sixth Ward, the former political district northwest of Downtown was created out of the Fourth Ward north of Buffalo Bayou in the 1870s. The mostly residential neighborhood is significant for its high concentration of Victorian-era homes. By designating the Old Sixth Ward a protected historic district, the City of Houston took its strongest action yet to preserve historic structures.

OCTOBER 14, 1901

The First Edition of the *Houston Chronicle* Was Published

After *Houston Post* reporter Marcellus E. Foster dropped a week's pay into an oil well in Beaumont, he returned to town a rich man. Even though Houston had two daily newspapers, Foster and investors thought a lower-priced afternoon paper could compete. On this day in 1901, the *Houston Chronicle* hit the newsstands. Foster would later take on Jesse "Mr. Houston" Jones as a partner, and Jones himself would buy out the founder to take full control of the newspaper. In 1987, the Hearst Corporation bought the *Houston Chronicle*, Texas's largest daily newspaper, for $400 million.

OCTOBER 15, 1957

HISD Ordered to Desegregate

Today in 1957, a federal district court ordered Houston public schools desegregated "with all deliberate speed," but Houston Independent School District took its time. In 1959, the NAACP petitioned the court for action, and in 1960, the public schools slowly (and conditionally) opened to African American children. Full desegregation of HISD came in 1966.

OCTOBER 16, 1992

Space Center Houston Opened

Today in 1992, NASA opened Space Center Houston as a science and space exploration learning center. Almost immediately, it became one of Houston's top tourist attractions. As the official visitor center of NASA Johnson Space Center, Space Center Houston hosted more than one million visitors annually at its 250,000-square-foot site. The center featured more than four hundred space artifacts, permanent and traveling exhibits and the world's largest collection of moon rocks and lunar samples. Yes, that's a real 747 sitting outside. No, that's a fake Space Shuttle on top of it.

OCTOBER 17, 1960

Houston Awarded a Baseball Team

In 1957, George Kirksey and Craig Culling founded the Houston Sports Association (HSA) with the goal of getting a relocated or expansion baseball team to Houston. They convinced Harris County voters to approve a stadium and would meet other team owners hoping to coax them to relocate. None accepted, so the HSA joined with other like-minded cities to start the Continental League. The existing American and National Leagues, compelled by antitrust laws and fearing competition from another league, agreed to expansion teams. When the Houston delegation arrived in Chicago for a meeting with league owners, new HSA member Roy Hofheinz brought a scale model of the future Astrodome to

convince them that Houston was dead serious on getting a baseball team. On this day in 1960, Houston was awarded a National League baseball franchise, what would become the Houston Astros.

OCTOBER 18, 1926

Houston Public Library Opened

Houston had enjoyed a public library donated by Andrew Carnegie since 1904, but the booming city eventually outgrew it. In 1922, voters approved a central public library, and today in 1926, Houston Public Library opened Downtown. Houston's first professional librarian, Julia Ideson, fought for the new building, which was renamed in her honor in 1955. The 1926 structure added a wing in 2011 and houses the Houston Metropolitan Research Center, a great place to become a Houstorian.

OCTOBER 19, 1974

The Woodlands Grand Opening

Today in 1974, oilman George Mitchell's master-planned community celebrated its grand opening. Ten years earlier, Mitchell had bought the Grogan's Lumber Company site north of Houston as the first property, and by the time of its opening, The Woodlands covered over seventeen thousand acres. Since its founding, The Woodlands has successfully resisted annexation by the City of Houston.

OCTOBER 20, 1945

The Texas Medical Center Was Chartered

In 1936, cotton tycoon Monroe Dunaway Anderson of Anderson, Clayton & Company created a trust with $10,000, and upon his death in 1939, he left $19 million to the M.D. Anderson Foundation. In 1941, the Texas legislature approved $500,000 for a future state cancer hospital and research facility, to be run by the University of Texas. Houstonians Dr. E.W. Bertner and Dr.

Frederick Elliott had sought to land a medical school for Houston and teamed up with M.D. Anderson Foundation trustees to create a cancer hospital instead (UT already ran a medical school in nearby Galveston). With the offer of land for the new institution, the Texas legislature agreed on Houston as the site, adjacent to existing Hermann Hospital. This new medical center would include Hermann Hospital, the Crippled Children's Hospital, the Houston Tuberculosis Hospital, the Houston Dental College and the Harris County Blood Bank. With help from the M.D. Anderson Foundation, Dallas's Baylor University College of Medicine moved onto land purchased from the City of Houston. Today in 1945, representatives from M.D. Anderson and the allied institutions signed the charter and filed it with the State of Texas, marking the birth of the Texas Medical Center. In the next decade, St. Luke's Hospital, Methodist Hospital and Texas Children's Hospital would join the expansive campus.

OCTOBER 21, 2002

Houston Rockets Signed Yao Ming

Yao Ming wasn't the first foreign-born player to be selected with the number-one pick in the NBA draft. He wasn't even the first foreign-born player the Rockets had selected with the number-one pick. (Perhaps you've heard of Hakeem Olajuwon?) But Yao does hold the distinction of being the first player chosen with the number-one pick who had never played competitively in the United States. For this reason, his selection was looked on with suspicion by noted basketball pundits like Bill Simmons and Charles Barkley. But he became a perennial All-Star, and he popularized the NBA in China, where Yao remains one of the most famous and accomplished athletes. Chronic injuries kept Yao from reaching his full potential, but you still see his jersey on Houston Rockets fans, and he was inducted into the Naismith Memorial Basketball Hall of Fame in 2016.

OCTOBER 22, 1937

Tower Community Center in Montrose

In the 1930s, Interstate Circuit was building neighborhood movie theaters across the United States, outside major metropolitan downtowns. In 1936, at the corner of Westheimer and Waugh Drive, the 1,200-seat Tower Theater opened to much fanfare. The single-screen movie house would be the anchor to the adjacent Tower Community strip center, which opened today in 1937. The Art Deco structure, designed by architect Joseph Finger, has been updated slightly over the years. However, it remains a fixture in Montrose, stubbornly resisting the slow gentrification of its neighbors, yet also strangely vulnerable to sale and demolition like so many other landmarks in Houston. The Tower Theater, which spent time as a performance venue, nightclub and video store, appears safe now that El Real restaurant occupies the shell.

OCTOBER 23, 1909

President Taft Visited

Following a trip through Texas, where he met the president of Mexico and rested at his brother's Corpus Christi ranch, President William Howard Taft arrived in Houston by train on this day in 1909. Owing to the Confederacy's resurgent popularity at the time, the president acknowledged the "South" and received honors from the Daughters of the Confederacy. Tens of thousands of patriotic Houstonians crammed into the intersection of Texas and Main to see Taft give a brief speech from the Rice Hotel balcony.

OCTOBER 24, 1946

Mercury Airlines

Trailways Bus Company founder Temple Bowen launched Mercury Airlines, based in Houston, today in 1946. Even though he had lost money on previous airline ventures, Bowen succeeded in providing service to discharged servicemen following the close of World War II, with a fleet of Douglas DC-3s.

OCTOBER 25, 1945

UH in Lone Star Conference

On this day in 1945, the Lone Star Conference invited the University of Houston to join its intercollegiate athletic league. UH students had been petitioning for basketball and football teams, and the next season, they got their wish. Cougar football took to the field against Southwestern Louisiana Institute. UH would leave the conference after the 1948 season.

OCTOBER 26, 1987

Houston Oilers' Dome Renovation

Bud Adams, who owned the American Football League's Houston Oilers, was a member of the Houston Sports Association, the group that built the Astrodome and got a Major League Baseball team to Houston. Even though the Astrodome opened in 1965, Adams's Oilers continued to play at Rice Stadium until a deal could be made between Adams and the HSA's Roy Hofheinz; the Oilers' first game at the Astrodome was in 1968. While it was primarily a baseball stadium, the Dome's playing field seats could be rotated into a rectangular configuration to accommodate a football field. In the mid-1980s, Bud Adams sought to increase seating by ten thousand and add sixty-five more luxury skyboxes, and he threatened to move the beloved Oilers to another city if his requests weren't met. On this day in 1987, Astrodome owner Harris County agreed to alter the Dome through a $67 million bond. This meant the scoreboard featuring the fan-favorite light show Home Run Spectacular and Hofheinz's opulent suite would be removed. Ultimately, Adams moved the team anyway, heading to Tennessee after the 1996 season. And while Bud died in 2013, the renamed Tennessee Titans are now owned by his family.

OCTOBER 27, 1990

Houstonian Patrick Swayze Hosted *Saturday Night Live*

While not the first Houstonian to host *Saturday Night Live* (that would be Shelley Duvall), and not the funniest Houstonian to host it (Jim Parsons),

movie actor and former Houstonian Patrick Swayze, riding high from recent hits *Ghost* and *Dirty Dancing*, appeared in "Chippendales," the funniest sketch in the show's history, on this day in 1990. The premise was so simple: two young exotic dancer hopefuls audition side by side. Swayze, before making it as a movie star, trained as a dancer in Houston, so he had the body and the moves to prove it. Did we mention the fat-but-always-confident Chris Farley was competing with him onstage? Both fully committed to the flashy 1980s dance moves. Both were hilarious, but in opposite ways. With Swayze playing it straight, goofball Farley matched the dancer's moves earnestly and energetically, cementing his anything-for-a-laugh reputation.

OCTOBER 28, 1972

Montrose Gaze Opened

On this day in 1972, the Montrose Gaze Community Center opened, the first such facility serving Houston's gay community. After seeing the turnout at Dallas's first gay pride parade, a group of Houston gay men contemplated fighting apathy and mobilizing. At the time, most gay rights activism was limited to college campuses, but the grungy Inner Loop neighborhood Montrose, where rents were low and the political vibe was progressive, had a large concentration of homosexuals (alongside hippies, artists and intellectuals). While the Montrose Gaze remained politically neutral, Houston gays and lesbians became more visible and active as the 1970s progressed. The community center quietly faded away sometime after 1973.

OCTOBER 29, 1969

Andy Warhol in Houston

In the late 1960s, John and Dominique de Menil had already begun to make a splash in the Houston art scene. Even though the couple had been art collectors for decades, they made their next impact in academia. In 1954, the de Menils partnered with the University of St. Thomas, and by 1964, Mrs. de Menil had taken over the Art History Department. Growing conservative policies eventually conflicted with the agenda of the de Menils, who were also growing advocates for social justice issues and civil rights.

The two found a new home for their collection at nearby Rice University, where they founded the Rice Media Center. In 1969, John and Dominique attended the closing of Rhode Island School of Design Museum's show "Look Back: An Exhibition of Cubist Paintings and Sculptures from the Menil Family Collection," where the museum director gave the couple a tour, which included the storage facilities. They were surprised to find so much hidden away from the public and hatched an idea for an exhibition where a contemporary artist would select works from storage. They invited their friend and legendary visual artist Andy Warhol. No one was surprised at Warhol's choices, which included mundane objects like shoes, parasols and chairs. Warhol made the bold choice to display the works as he first discovered them in storage. On this day in 1969, Warhol's *Raid the Icebox 1* opened at Rice University's Institute for the Arts.

OCTOBER 30, 1974

Rumble in the Jungle

Everyone loves the genial TV pitchman and motivational speaker George Foreman (and his George Foreman Grill), but few remember him as the imposing world heavyweight champion boxer from Houston's Fifth Ward. On this day in 1974, in Kinshasa, Zaire, undefeated Foreman lost to Muhammad Ali by knockout in the heavily promoted Rumble in the Jungle. Ali, who in 1967 was stripped of his championship title and barred from boxing after refusing the military draft (in a Houston courtroom), reclaimed the title after years in political and social exile. Check out the documentary film *When We Were Kings*, with Foreman cast as the villain and Ali shrewdly wearing him down with the now-famous rope-a-dope strategy. Foreman retired in 1977 but gloriously snatched back the heavyweight title in 1994—at age forty-five!

OCTOBER 31, 1948

The Contemporary Arts Association's First Exhibition

In the mid-twentieth century, Houston could not boast of being an international city. Yes, there was the symphony and the Museum of Fine Arts,

but other cultural institutions were years away. When John and Dominique de Menil moved to Houston in 1941, they brought with them their European sensibilities, their growing art collection and their commitment to serving the community. A small group of collectors and academics asked John to serve on the board of the new Contemporary Arts Association (CAA). On this day in 1948, the CAA opened its first exhibition, "This Is Contemporary Art." The CAA would partner with the more established Museum of Fine Arts, but the group's full independence came with the opening of its own space (across the street) in 1972 as the Contemporary Arts Museum.

NOVEMBER

NOVEMBER 1, 2017

Astros Won the World Series

When the 2017 Major League Baseball season began, eight teams had never won a World Series. But on this day in 2017, the Astros could finally cross their name off that ignominious list. The team was just three seasons removed from one of the lousiest four-year runs in professional sports history. It was a stretch where losses were tallied in the triple digits, where tens of thousands of seats at Minute Maid Park sat empty every night, where televised games were routinely scoring a 0.0 in the local ratings. It was grim. But led by eventual American League MVP Jose Altuve, along with stellar homegrown talents like George Springer, Carlos Correa, Alex Bregman and Marwin Gonzalez, the 2017 Astros won 101 games on their way to their first

Houston Strong patch.
Author's collection.

American League West title. With the city still reeling after the devastation of Hurricane Harvey, the Astros made a last-minute, late-season trade for one of the best pitchers of the twenty-first century, a future Hall of Famer, Justin Verlander. Suddenly, a great team was even better, and they were well positioned for the playoffs. And for a city that was desperate for a bit of positive news to help bolster its spirit, they were Houston Strong. The Astros went on to beat three of the most storied franchises in sports: the Boston Red Sox, the New York Yankees and, finally, the Los

Angeles Dodgers, to win it all. Players like Jeff Bagwell, Craig Biggio and Nolan Ryan are Hall of Famers and Houston sports legends. But the 2017 Astros did something that those players never could: they brought a World Series title to Houston.

NOVEMBER 2, 1939

The Alabama Theater Opened
Today in 1939, the Alabama Theater had its grand opening. The Art Deco, single-screen movie theater anchored the Alabama Center, named for its location on Shepherd and West Alabama. Showing first-run movies until the 1980s, the theater quickly lost customers to multiplexes and home video. In 1984, Bookstop, an Austin-based bookstore chain, lovingly restored the recently vacated movie house into a glorious example of historic preservation. Houstonians, accustomed to demolition of beloved landmarks (especially theaters), were equally shocked and charmed by the renovation. Houstonians had also never seen a mega-bookstore. And just as the Alabama lost business to multiplexes and home video, Bookstop (bought by Barnes & Noble) eventually lost business to online retailers. When Barnes & Noble moved to the River Oaks Shopping Center, landlord Weingarten Realty removed the sloped floor, stage and all architectural distinctiveness, hoping a blank interior would have a greater appeal to a new tenant. It's now home to Trader Joe's, which gamely tries to play to the theater's history with movie pun advertising. Ironically, the theater that was once the best example of historic preservation and adaptive reuse is now the lamest.

NOVEMBER 3, 2017

Astros Parade and Rally
Today in 2017, just two days after winning their first World Series, the Houston Astros were celebrated in a Downtown victory parade and rally at City Hall. Sure, Houston had seen previous championship parades (Rockets, Comets), but this one was different. Houston Independent School District, fearing faculty and staff would be no-shows, cancelled classes so all could cheer the champion baseball team. Hours before the parade,

Downtown parking garages were overflowing with eager fans. And even though that Friday was unseasonably warm, no one seemed to notice or care. Starting before noon, a seemingly endless wave of Houstonians in Astros orange filled Downtown streets, forcing the parade route to be extended a few blocks. The anticipation was as thick as the humidity. Players, coaches and everyone in the Astros family rode on firetrucks, greeted by an estimated 750,000 jubilant fans, some who had waited fifty-six years to see Houston win it all. Orange and blue confetti showered down. Grown men wept seeing Astros Hall of Famers Craig Biggio and Jeff Bagwell ride by, waving to the crowd; championship rings

Astros rally at City Hall. *Courtesy of Anita Hollmann.*

had eluded both in their storied careers. Notably absent was new Astros pitcher Justin Verlander, who was en route to his own wedding. The parade ended on the steps of City Hall, where the team was greeted by local and state elected officials, eager to be photographed with the Houston heroes. All made short speeches, and the World Series trophy was hoisted high for everyone to see. More confetti flew. The party lasted into the night, with Downtown bars overflowing with happy fans still clinging to rally signs. Well into the weekend, high-rises kept their celebratory messages spelled out in lit windows, and City Hall remained illuminated in Astros orange for days.

NOVEMBER 4, 1974

"I Can See Clearly Now" Was Number One

45 record. *Author's collection.*

Today in 1974, Billboard ranked Houstonian Johnny Nash's "I Can See Clearly Now" as the nation's number-one song. Nash, who grew up in the Third Ward, was a singing teen idol on local TV in the 1950s and scored some modest hit songs in the early 1960s. In 1965, he left Houston for Jamaica, where he befriended and signed future reggae superstar Bob Marley to his new label, but the two couldn't

muster any hit songs. Nash's hopeful, Jamaica-flavored "I Can See Clearly Now," after being covered by hundreds of artists, is now considered to be an American standard.

NOVEMBER 5, 1958

First African American Elected to the HISD Board of Trustees
While Houston remained racially segregated, former schoolteacher Hattie Mae White was elected to the school board on this day in 1958. Fighting the current "separate but equal" status quo, White, who was African American, sought to desegregate Houston's schools despite years of resistance from fellow board members. Even though she drew support from both African American and white voters, White was denied a third term. Houston Independent School District named two administration buildings in her honor.

NOVEMBER 6, 1528

Cabeza de Vaca Landed in Galveston
After surviving a failed expedition to Florida, shipwrecked Spanish explorer Álvar Núñez Cabeza de Vaca and his crew landed near Galveston Island on this day in 1528. Immediately, Cabeza de Vaca was enslaved by the native inhabitants, but he escaped a year later and traded with friendly natives as he traveled the mainland, making him the first European to visit present-day Houston. In 1532, he and three survivors of his party traveled for four years on foot across Texas and into Mexico, which was under Spanish rule, eventually making it to Mexico City. In 1987, the City of Houston installed a bronze bust of Cabeza de Vaca on a granite pedestal in the International Sculpture Garden (now McGovern Centennial Gardens) in Hermann Park.

NOVEMBER 7, 1975

The Summit Opened

Today in 1975, Houston's new $18 million sports and entertainment venue The Summit opened in Greenway Plaza facing the Southwest Freeway. Although it was built as the San Diego Rockets' new basketball arena, the World Hockey Association's Houston Aeros shared the space, as well as the traveling Ringling Brothers Circus and countless ice shows. The Who played the first concert there on November 20, and hundreds of concerts would follow until ZZ Top rocked the house one last time in 2003. The WNBA's Houston Comets had four championships there but could never reclaim the same magic after leaving The Summit. Following nearly twenty years and two world championships in The Summit (renamed Compaq Center in 1998), Rockets owner Les Alexander negotiated for a new Downtown arena. When the Toyota Center opened in 2003, the Houston-owned Summit was without its signature tenant. The feel-good Lakewood Church swooped in, signed a thirty-year lease and converted it for its congregation. In 2010, Lakewood took The Summit off Houston's hands for a cool $7.5 million (no word on whether they kept The Summit's peppy organ up in the rafters).

The Summit logo. *Author's collection.*

NOVEMBER 8, 1966

Barbara Jordan Was Elected

On this day in 1966, Houston native Barbara Jordan won her first political victory when she was elected to the Texas Senate—the first African American woman to do so. While in Austin, she wrote the first successful minimum-wage bill in the state of Texas and served as "Governor for a Day" while appointed to the role of president pro tempore in 1972. She would later represent Houston in the U.S. Congress for three terms. Her friend and mentor President Lyndon Johnson provided counsel and assistance getting Jordan onto the powerful House Judiciary Committee, where she received national recognition during the Watergate scandal hearings.

NOVEMBER 9, 1989

Houston Press News and Entertainment Weekly Debuted

Today in 1989, the weekly alternative newspaper the *Houston Press* debuted. Founded by John Wilburn and Chris Hearne, the so-called alt-weekly was a welcome addition to Houston, where the only thing close was the grungy, Montrose-centric *Public News*. With heavy local arts, music and political reporting, the *Press* was Houston's version of the *Austin Chronicle* or New York's *Village Voice*. The *Houston Press* also introduced the community to such distinct Houston voices as Tim Fleck, Michael Berryhill, Shaila Dewan, William Michael Smith, John Nova Lomax, Chris Gray, Cathy Matusow, Robb Walsh, Craig Malisow and Lisa Gray. Its "Best of Houston" and "*Houston Press* Music Awards" led hundreds of young Houstonians into deeper explorations of the Houston scene. In the 2000s, as with so many other media outlets, the *Houston Press* struggled to find readers and advertisers. During the Astros' victory rally, the twenty-eight-year-old *Press*, still hurting from loss of advertising revenue in the wake of Hurricane Harvey, laid off most of its staff. While the online version still employs freelance writers, the future of Houston's alt-weekly remains uncertain.

NOVEMBER 10, 1914

Ship Channel Celebration

Since the birth of Houston in 1836, city planners, politicians, merchants and industrialists wanted to make Houston a port city. They dreamed of commercial traffic coming by ship from the Gulf of Mexico, up Galveston Bay and into Buffalo Bayou, where Houstonians could ship their goods.

The Ship Channel dedication ceremony. *Courtesy of Port Houston.*

In the early twentieth century, Houston boasted seventeen railroads that brought cotton, rice and lumber to oceangoing vessels. As ships increased in size, Buffalo Bayou was dredged deeper and deeper. In 1911, voters approved the creation of the Port Authority and a bond to pay for dredging the Ship Channel to twenty-five feet deep from Allen's Landing at Main Street to Galveston Bay. The so-called Houston Plan would also include matching federal money. On this day in 1914, Houstonians celebrated the improvements at the Ship Channel, with President Woodrow Wilson opening the celebration with a cannon fired by remote control from Washington.

NOVEMBER 11, 2009

Houston Cinema Arts Festival Debuted

In 2007, Mayor Bill White saw a lack of filmmaking and film appreciation in Houston and asked arts philanthropist Franci Crane to improve overall film culture in Houston. She recommended Houston sponsor cinematic programming that focused on films "by and about artists." If Houston were to be seen as a thriving arts town, then it would need to celebrate innovative films, media installations and performances. Houston Cinema Arts Society (HCAS) was founded in 2008, and on this day in 2009, it launched its inaugural five-day Houston Cinema Arts Festival. Since then, HCAS has grown to host a variety of initiatives and programs and a schedule of year-round screenings, events, performances and guest lectures, but its most ambitious event continues to be the annual Houston Cinema Arts Festival. Now eight days, this multi-venue festival includes over fifty narrative and documentary films, an interactive video installation gallery, live multimedia performances and panel discussions.

NOVEMBER 12, 1983

Downtown Swarm

Today in 1982, millions of katydids swarmed Downtown Houston. Like the ubiquitous local cockroach, the katydids were most likely spared by a light winter, allowing them to maintain a strong population. The insects hit Main Street the hardest, blacking out windows and forcing custodians

to become exterminators. Because most Downtown office workers chose the tunnels over (under?) sidewalks, few noticed the mini-plague. Showing overabundance of caution, some Jewstonians put lamb's blood on their front doors.

NOVEMBER 13, 1888

Telephone Service in Houston

Public telephone service came to Houston in 1878, when Western Union installed a temporary line for demonstration purposes, and the first commercial telephone exchange began a year later. Subscriptions grew gradually as service expanded and improved. On this day in 1888, the City of Houston allowed Erie Telegraph and Telephone Company to install poles on city streets for telephone lines.

NOVEMBER 14, 1997

Aerial Theater Opened at Bayou Place

In 1987, the Albert Thomas Convention Center was replaced by the shiny new George R. Brown Convention Center on the opposite end of Downtown. Looking to find a new use for the building, the City of Houston partnered with East Coast developer the Cordish Company, which revived the obsolete building into Bayou Place, a 130,000-square-foot entertainment destination, with restaurants, a movie theater and live music venue Aerial Theater, which opened on this day in 1997. At the time, Downtown nightlife was scarce, and ever since the Music Hall closed, Houstonians weren't able to see a mid-size rock concert Downtown. Even though the name seems to change every few years, the venue, now known as Revention Music Center, is an indispensable member of the Theater District.

NOVEMBER 15, 1919

Port of Houston Shipped Cotton to Europe

In the early twentieth century, cotton was big business in Houston. Following the celebrated dredging of the Ship Channel, much larger vessels could get the local crop to markets beyond the Gulf of Mexico. On this day in 1919, the first direct-to-Europe cotton shipment left Houston on the *Merry Mount*. By the end of the 1920s, Houston would become the leading cotton exporter in the nation.

NOVEMBER 16, 1970

The Galleria Opened

On this day in 1970, developer Gerald Hines opened The Galleria, his most ambitious project to date. Modeled after the Galleria Vittorio Emanuele II in Milan, and with 600,000 square feet of indoor shopping on three levels, the new mall boasted 60 percent occupancy on opening day. Multi-level parking garages surrounded the mall so shoppers could park close to their favorite stores. The lowest level of The Galleria boasted a cheery ice-skating rink, with views from upper levels, forcing many to wonder, "Can Houstonians ice-skate?" Rumor has it that anchor tenant Neiman Marcus was lured to Houston with free rent. Office buildings, hotels and movie theaters joined chain stores and restaurants in the tony mall at Westheimer and Post Oak Boulevard. Other neighboring developments, including Sakowitz, Saks Fifth Avenue and Tony's, helped make that intersection the go-to destination for both local and international shoppers. Over the years, The Galleria has added wings and seems to redo its interior every other year. Gone are the movie screens and arcades, but The Galleria has grown to 2.4 million square feet, and its mere name has become a nickname for the entire area.

NOVEMBER 17, 1981

Mayor Kathy Whitmire

Today in 1981, City Controller and native Houstonian Kathy Whitmire won the Houston mayor's race in a runoff with Harris County sheriff Jack

Heard, becoming the first woman to hold that office. Even though Houston's mayoral elections are nonpartisan, Whitmire was voted into office from strong support by women, African Americans and gays. She ran unopposed for her second term and appointed Lee Brown as Houston's first African American police chief (he would later be Houston's first black mayor). Whitmire also gave Sylvia Garcia her start in politics by appointing her a judge in municipal court. Kathy Whitmire would serve five terms and end her political career following her defeat to Bob Lanier in 1991.

NOVEMBER 18, 1977

National Women's Conference
Today in 1977, the federally funded National Women's Conference was held in Houston, in conjunction with the United Nations' International Women's Year. Nearly two thousand elected delegates attended and helped write a National Plan of Action, later presented to President Jimmy Carter and Congress. For four days, twenty thousand participants came to hear from First Ladies Rosalyn Carter, Betty Ford and Lady Bird Johnson, alongside Barbara Jordan, Bella Abzug, Coretta Scott King and Betty Friedan, at the conference, the largest political meeting of women in the United States since 1848's Women's Rights Convention in Seneca Falls, New York.

NOVEMBER 19, 1985

Pennzoil's Big Win
Today in 1985, Pennzoil won a $10.53 billion judgement against Texaco in the largest civil verdict in U.S. history. Texaco, the nation's third-largest oil company, had tried to interfere with a previous deal between Pennzoil and Getty, where Pennzoil would purchase a percentage of Getty. Following *Pennzoil v. Texaco*, lead attorney Joe Jamail was dubbed the King of Torts.

NOVEMBER 20, 1978

Earl Campbell and Luv Ya Blue

In the late 1970s and early 1980s, Houston's pro football team, the Oilers, captured the imagination of the city, which embraced them wholeheartedly, win or lose. Among the talented and colorful players, no one was more beloved than Earl Campbell. Today in 1978, Campbell, a Heisman Trophy–winning running back from the University of Texas and a rookie during the 1978 season, secured his place in the pantheon of Houston sports. The Tyler Rose scored four touchdowns, rushed 199 yards, had a career-defining 81-yard run and led Houston to victory over the Miami Dolphins in front of a national TV audience. "Luv Ya Blue" was born.

Luv Ya Blue fan sign. *Author's collection.*

NOVEMBER 21, 1963

JFK's Last Day

Today in 1963, President John Kennedy spent the last full day of his life. On a short trip through Texas, the president and first lady stopped in Houston and rested at the Rice Hotel, where he had a few meetings. Before attending a scheduled fundraiser for NASA champion congressman Albert Thomas, the president and first lady stopped by an event hosted by the League of Latin American Citizens (LULAC). JFK gave a seventeen-minute speech, and then First Lady Jackie Kennedy spoke to the group in Spanish. After a few hours in Houston, the couple flew to Fort Worth for the night.

NOVEMBER 22, 1968

Lynn Eusan at University of Houston

Student activist Lynn Eusan became the first African American homecoming queen for the predominantly white University of Houston. Following several

civil rights victories on campus, she graduated in 1970 and started a career in journalism while continuing to be an organizer in the black community. Tragically, she was murdered in 1971. The University of Houston dedicated Lynn Eusan Park on campus in her honor.

NOVEMBER 23, 1964

First Coronary Artery Bypass
On this day in 1964, Houston cardiovascular surgeon and inventor Dr. Michael DeBakey and his team, treating a stroke, performed the world's first successful coronary artery bypass graft surgery, using a transplanted leg vein to reroute blood around blocked coronary arteries. DeBakey would go on to develop and implant the first successful ventricular assist device. Other innovations from DeBakey included the roller pump for open heart surgery, the Mobile Army Surgical Hospital, artificial arteries and the artificial heart (with Robert Jarvik).

NOVEMBER 24, 2007

First Catholic Cardinal
Today in 2007, Galveston-Houston Archbishop Daniel DiNardo was made the first Catholic cardinal from Texas. DiNardo came to Galveston-Houston, an archdiocese of 1.3 million Catholics, in 2004 and was appointed as its archbishop in 2006. As a cardinal, DiNardo would be a papal elector, when required. In 2016, the U.S. Conference of Catholic Bishops elected DiNardo as its president.

NOVEMBER 25, 1954

Elvis Rocked Houston
Today in 1954, Elvis Presley played his first gig in Houston, at the Paladium Club, on Old Spanish Trail at Main Street. Even though nobody knew about the future King of Rock & Roll (the ads misspelled his name

"Pressley"), he played two additional nights in the small nightclub and returned for two more shows at Christmas and a few times in the spring of 1955. In the 1970s, Elvis played the Rodeo several times before his death in 1977.

NOVEMBER 26, 1968

Alley Theatre Opening Night

On this day in 1968, the new home for the Alley Theatre had its grand opening, with Mayor Louie Welch and thirty-seven astronauts attending the inaugural production of Bertolt Brecht's *Galileo*. Architect Ulrich Franzen's Brutalist design was a shocking addition to Downtown, but it paved the way for more daring Downtown architecture in the 1970s and 1980s. This third and current location in the Theater District was funded in part by a $2.1 million grant from the Ford Foundation.

NOVEMBER 27, 1917

Ellington Field Opened

On this day in 1917, Ellington Field, the nation's largest pilot training base and first aerial bombing school, opened southeast of Houston, adjacent to Clear Lake. During World War I, it housed twenty thousand men and 250 aircraft, but it closed following the war and was only partially used until World War II. Since then, it became the Gulf Coast's strategic defense base and defended the Houston Ship Channel and the nearby oil refineries. The Houston Airport System created Ellington Airport in 1984 on a portion of the site, also home to Houston Spaceport, the nation's tenth licensed commercial spaceport. The Texas State Guard, NASA and U.S. Coast Guard have used the site too. In 2017, the Lone Star Flight Museum relocated there.

NOVEMBER 28, 1939

River Oaks Theatre Opened

Today in 1939, the Art Deco movie house River Oaks Theatre opened. Designed to complement the new River Oaks Community Center shops, the River Oaks Theatre had a large single screen and modest Art Deco flourishes. By the 1970s, it had become home to offbeat, artsy flicks. In the early 1980s, the balcony was closed and divided into two small screens. In the early 2000s, a bar was added upstairs.

In 2007, Weingarten Realty, which had bought the center in 1972 and was constantly tinkering with the look of the shopping center, demolished the original 1937 curved portion of the first phase of the River Oaks Community Center. A new multi-level parking garage would soon stretch along the back side behind existing La Griglia from Shepherd to McDuffie Street. Weingarten stated nothing else. Its silence was deafening. All of Houston wondered, *Was this Phase One of a plan to wipe the vintage 1939 River Oaks Theatre off the map?* The gigantic garage hinted that more development would follow once the north side of West Gray was completed—perhaps a high-rise? Immediately, Houstonians rallied. In the days before social media, over twenty-six thousand people signed an online petition declaring their love for the Art Deco movie house, which, aside from closing off the balcony for two additional smaller screens and adding some less comfortable seats, had not changed much in seventy-eight years.

Average Houstonians became preservation activists. When Weingarten Realty boasted that bookseller Barnes & Noble would be moving into the new retail space across from the theater, the community was instantly alarmed that the existing home in the neighboring Alabama Theater at 2922 South Shepherd Drive (also from 1939) would be placed in the path of the wrecking ball once it moved down the street. Coincidentally, Weingarten Realty owned the historic Alabama Theater too.

Traditionally, Houston has allowed owners to decide the fate of their own properties, irrespective of the property's place in the fabric of the city. Houston's first preservation ordinance, adopted by the City Council in 1995, created the Houston Archaeological and Historical Commission (HAHC) to review applications for demolition or alteration of historic buildings. Its only power required owners to wait ninety days before proceeding on any alteration or demolition of a historic property. Most agreed this was useless. In 2007, City Council amended the existing Historic Preservation Ordinance to strengthen its power to designate buildings, structures or sites

with architectural, cultural or historical significance. Landmark status can be given by HAHC, without consent of the owner, and protects a property for ninety days. The more meaningful "Protected Landmark" status can be applied for by the owner and is nontransferable. Other benefits for properties granted Landmark or Protected Landmark status include financial incentives to assist in restoration and an increased penalty for illegal demolition.

The River Oaks Theatre has the lesser "Landmark" status, which means that should Weingarten wish to tear it down, it need wait only ninety days. Ultimately, the power to tear down remains with the property owner.

NOVEMBER 29, 1909

De-Ro-Loc No-Tsu-Oh Carnival

Today in 1909, Houston's African American community hosted the De-Ro-Loc No-Tsu-Oh Carnival, in response to the segregated No-Tsu-Oh, in the Third Ward's Emancipation Park. The early twentieth-century festivals, which favored backward spellings of "Houston" and "Colored," patterned themselves after Mardi Gras, with performances, exhibits, concessions and, in subsequent years, football games between black colleges. The De-Ro-Loc No-Tsu-Oh Carnival was popular throughout the region and ran yearly until 1919.

NOVEMBER 30, 1836

Houston Voted Capital of Texas

On this day in 1836, the First Congress of the Republic of Texas voted to make Houston the capital, relocating from the temporary site in Columbia. Part of the Allen brothers' scheme for their new town on Buffalo Bayou was to ensure the capital had a home there. To sweeten the offer, they donated buildings for the government and lodgings for congressmen. The new government began operation there the next year in an unfinished building on the corner of Main and Texas. Not everyone was convinced of Houston's virtues, and in 1839, the capital moved to the town of Waterloo, soon renamed Austin.

DECEMBER

DECEMBER 1, 1969

Hofheinz Pavilion Opened

On this day in 1969, the University of Houston opened its new sports and performance venue, Hofheinz Pavilion, where the Houston Cougars men's basketball team defeated Southwestern Louisiana 89–72 before a crowd of seven thousand. It was later home to the Houston Rockets before the Summit opened in 1976. It hosted graduations and rock concerts, including Elvis Presley, the Rolling Stones, Led Zepplin, Prince and Madonna. The building was named in honor of Roy Hofheinz's wife, Irene Hofheinz, and the basketball court in honor of Coach Guy V. Lewis. In November 2015, the Board of Regents approved a $60 million renovation, with a $20 million gift from UH alumnus Tilman Fertitta and the blessing of the Hofheinz family.

DECEMBER 2, 1984

The First SPARK Park

Following a request by the mayor and county judge to assess Houston's parks, a panel recommended that the city develop neighborhood parks on public school grounds—a fast and cost-effective way to increase park space. On this day in 1984, the first SPARK Park opened at Gregory-

Lincoln Elementary School in Freedmen's Town. Originally led by Council Member Eleanor Tinsley, SPARK has built over two hundred community parks in twelve different school districts throughout the Houston area. Each park is designed based on input from the host school and the surrounding neighborhood and consists typically of playground equipment, walking trails, benches, picnic tables, trees and public art (many times with art made by the students themselves). SPARK is funded through donations from local businesses and endowments.

DECEMBER 3, 1939

Move-In Day at City Hall

Today in 1939, Houston's new City Hall opened. The limestone-clad Art Deco structure replaced the Market Square City Hall, where, from 1841 to 1939, four different wood-frame buildings were located. The new City Hall featured a reflecting pool and public park in front that has been used by Houstonians to gather in times of celebration and in times of protest. City Hall is occasionally lit with thematic colored lights honoring causes, holidays or even world championships.

DECEMBER 4, 2012

"Mind Playing Tricks on Me" Ranked Fifth

Today in 2012, *Rolling Stone* magazine ranked Houston's the Geto Boys' paranoid hip-hop masterpiece "Mind Playing Tricks on Me" as the fifth greatest hip-hop song ever. The Geto Boys, Houston's first nationally recognized hip-hop group, was founded in 1986 and released what would become the group's signature song on the 1991 album *We Can't Be Stopped*. Current members include Bushwick Bill, Scarface and Willie D.

DECEMBER 5, 1911

Galveston-Houston Electric Railway Opened

Today in 1911, the Galveston-Houston Electric Railway began service, connecting Downtown Houston to Galveston Island with trolley cars on a

dedicated track and over the newly completed Galveston Causeway. Hourly service cost $1.25 and could be completed in as little as ninety minutes. The so-called interurban rail ran until 1936, when the popularity of automobiles weakened interest in multiple public transportation projects.

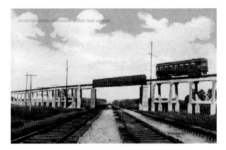

Interurban train. *Author's collection.*

DECEMBER 6, 1873

Buffalo Bayou Dredged

The Buffalo Bayou Ship Channel Company had started dredging a channel across Morgan's Point in 1872, but the work was interrupted by the financial Panic of 1873. On this day in 1873, Houston mayor Thomas Scanlan petitioned Congress for federal aid to continue dredging to six feet deep. The next year, government engineers recommended that the ship channel be deepened to twelve feet rather than six. In the present day, the Ship Channel is forty-five feet deep.

DECEMBER 7, 1935

Worst Flood to Date

Before Houston became the biggest city in Texas, major floods hurt local interests, especially adjacent to Buffalo Bayou, where rainwater runoff takes its time on the low slope to Galveston Bay. But in modern commercial Houston, "where seventeen railroads meet the sea," catastrophic floods have national economic ramifications. In the early twentieth century, big-time Houston couldn't afford to lose its hard-won role as one of the nation's largest ports where lumber, sugar and rice were shipped worldwide and

the world's largest inland cotton market thrived. And nothing, city leaders argued, should jeopardize our oil industry that had set up shop along the twenty-five-foot-deep, fifty-mile-long Ship Channel. A massive flood in 1929 came during the drafting of a plan from the newly formed City Planning Commission, which, among other things, recommended dredging all bayous to accelerate runoff. Criticism from land developers meant that little from the plan was actually realized. On this day in 1935, Houston's worst flood to date occurred, with seventeen inches of water on Downtown streets, claiming twenty-five blocks and countless residences and shutting down the Port of Houston for months.

DECEMBER 8, 1991

Nelson Mandela Visited

Today in 1991, Nelson Mandela received the Carter-Menil Human Rights Award at the Rothko Chapel from President Jimmy Carter and Dominique de Menil. The African National Congress president and former political prisoner visited the United States after twenty-seven years of incarceration in his native South Africa. Later that day, Texas Southern University awarded him an honorary doctorate.

Governor Ann Richards, President Nelson Mandela, Dominique de Menil and Rodney Ellis. *Courtesy of Rodney Ellis.*

DECEMBER 9, 1977

The Punch

Today in 1977, Los Angeles Laker Kermit Washington hit Houston Rocket Rudy Tomjanovich in a fight that broke out during a basketball game, leaving Rudy T with a fractured face, unconscious and nearly dead. The doctor who treated him said the force of the blow was roughly the equivalent of being thrown from an automobile going fifty miles per hour. The four-time All-Star would make a full recovery, play on one more All-Star team and lead the Rockets as head coach to back-to-back NBA championships in 1994 and 1995.

DECEMBER 10, 1904

Wards Abolished

Today in 1904, Houston voters approved ending the ward system of municipal government. The political district/governing system, established in 1840, provided each of Houston's six wards with two elected aldermen to serve on City Council. The original four wards were created at the intersection of Main Street and Congress Street. The Fifth Ward was created out of the First and Second Wards in 1866, to the east of White Oak Bayou and to the north of Buffalo Bayou. The Sixth Ward was created out of the Fourth Ward north of Buffalo Bayou in the 1870s. Wards were officially abolished in 1915, but even today, the names are used by many as a show of neighborhood pride.

DECEMBER 11, 1996

Jack Yates House Reopened

Today in 1996, the 1870 Jack Yates House reopened in Sam Houston Park, after relocation and renovation. Originally located at 1318 Andrews Street in Freedmen's Town, the home was built by the Reverend John Henry "Jack" Yates, an emancipated slave. Yates served as the minister for Antioch Baptist Church, founded Bethel Baptist Church and helped to organize the Houston Academy in 1894. Yates was buried in College Memorial Park Cemetery and has a high school named in his honor.

DECEMBER 12, 2009

Mayor Annise Parker

Today in 2009, native Houstonian, Rice University alumna and former city controller Annise Parker was elected mayor of Houston in a runoff. When she took office weeks later, she became the first openly gay mayor of a major U.S. city. She is the only person in Houston history to hold the offices of council member, controller and mayor. During her tenure, she assisted in reforming the city's crime lab operations, authorized a Downtown sobering center and created the Office of Business Opportunity, helping minority- and women-owned businesses compete for city contracts. In 2010, City Council approved a Historic Preservation Ordinance that provided protection for historic properties in city-designated historic districts. After three terms, she returned to private life, teaching and advocating. In 2017, she was named the president and CEO of the LGBTQ Victory Fund, charged with increasing the number of openly LGBTQ political candidates elected.

DECEMBER 13, 1882

Capitol Hotel Got Electricity

Today in 1882, the Capitol Hotel became Houston's first public building to get electricity. Months earlier, the new five-story, eighty-room brick Capitol Hotel had opened on the former site of the republic's capitol on Main Street. In 1887, Houston millionaire industrialist William Marsh Rice bought it and kept that name, but the trustees of his estate changed it to the Rice Hotel after Rice was murdered in 1900.

DECEMBER 14, 1926

Houston Grew to Seventy Square Miles

Today in 1926, the City of Houston annexed Harrisburg, River Oaks, Memorial Park and Cottage Grove, enlarging the city to seventy square miles. A major reason Houston grew to become the fourth-largest city in the United States is due to aggressive annexation. In fact, from the 1940s to the 1960s, Houston doubled its physical size twice. In the 1990s, general purpose

annexation was limited by state law following Kingwood's controversial re-annexation. Now, limited-purpose annexations allow the City of Houston to annex a territory with commercial properties through an agreement with the utility district (the provider of water and sewer service within that territory), where a limited list of services are provided, with a split sales tax and no collected property taxes.

DECEMBER 15, 1990

Majestic Metro Opened

Today in 1990, Market Square's Ritz Theater reopened as the Majestic Metro, a rentable events space. The former silent movie house was designed by famed Rice architect William Ward Watkin and stood apart from the larger movie palaces Downtown. The Ritz changed its name to the Majestic Theater in 1972 and, following years of blaxploitation and later porno films, went dark in 1984. Gary Warwick renovated it in an era when preservation in Houston was not commonplace. The reborn theater joined a recently restored Alabama Theater as examples of creative, sensitive historic preservation.

DECEMBER 16, 1961

Bill Hicks Was Born

Today in 1961, groundbreaking comedian Bill Hicks, who attended Stratford High School and got his start at Houston's Comedy Workshop, was born. Known for keen social commentary, experiments with mind-expanding drugs and philosophy, Hicks began his career at the Comedy Workshop on Shepherd. *Free Press* succeeded in raising money to honor him with a statue, but a location has not yet been decided.

DECEMBER 17, 1918

World War I Victory Sing

Today in 1918, a crowd of nearly fifteen thousand assembled Downtown in front of the Rice Hotel to honor the service of the Allied forces following the end of World War I.

DECEMBER 18, 1937

City-County Hospital Completed

Today in 1937, the City-County Hospital, renamed the Jefferson Davis Hospital after its predecessor, was completed. The Moderne-style public facility was designed by renowned architects Alfred C. Finn and Joseph Finger and built on a ten-acre site south on Buffalo Bayou, adjacent to Freedmen's Town. Following years of unfit conditions, understaffing and lack of funding, hospital volunteer Jan de Hartog exposed Jeff Davis Hospital's failings in his 1964 book *The Hospital*, which shamed the community into forming the Harris County Hospital District in 1965. The hospital closed in 1989 and was demolished in 1999.

DECEMBER 19, 1913

Houston Symphony Debut

Today in 1913, the Houston Symphony Orchestra hosted its first public concert, under direction of the Houston Symphony Orchestra Association. The matinee show at Downtown's Majestic Theatre sold tickets for three dollars, five dollars and twenty-five cents for gallery seats. Founder Ima Hogg had hosted a demonstration concert the previous June, but this public show proved that Houston could be home to permanent cultural institutions such as a resident symphony. Ima Hogg would spend the rest of her life sustaining the Houston Symphony.

DECEMBER 20, 1998

Octuplets Born

Today in 1998, Nkem Chukwu gave birth to octuplets, the first in the United States, at St. Luke's Hospital. She and her husband, Iyke Louis Udobi, welcomed six girls and two boys, with one dying a week later. The first child was born two weeks earlier.

DECEMBER 21, 1933

Grand Prize Beer Went on Sale

Today in 1933, Gulf Brewing Company, founded by Howard Hughes Jr. at the end of Prohibition, began selling Grand Prize Beer, which would later become the best-selling beer in Texas. Hughes's Grand Prize Brewery was built on the former site of Hughes Tool and shrewdly employed award-winning brewmaster Frantz Brogniez, who had won the grand prize at 1913's Universal and International Brewers Congress in Europe.

Grand Prize
beer can. *Author's
collection.*

DECEMBER 22, 1836

Harris County Founded

Today in 1836, the Republic of Texas First Congress formed Harrisburg County, honoring New York entrepreneur and Texas settler John Richardson Harris, founder of nearby Harrisburg, on Buffalo Bayou downstream from what would become Houston. The county, which would eventually include Houston, Baytown, Clear Lake, Cy-Fair, Pasadena and the Ship Channel, was renamed Harris County in 1839 to avoid confusion with the town.

DECEMBER 23, 2012

OKRA Opened

Today in 2012, the OKRA Charity Saloon opened in Market Square. The Organized Kollaboration on Restaurant Affairs was founded in 2011 as a loose affiliation of like-minded bar and restaurant owners to promote and advocate for charitable causes and lobby local government for improved industry standards and sympathetic civic ordinances. As an extension of OKRA's core beliefs, OKRA Charity Saloon donates 100 percent of its proceeds monthly to a charity voted on by the customers. To date, it has donated over $1 million to Houston charities.

DECEMBER 24, 2004

White Christmas

Today in 2004, Houston had its first white Christmas when snow fell on Christmas Eve. Both Newstonians and natives always joke about such impossibilities, laughing at the romantic premise that movies, songs and communities to the north take for granted. Try getting through local news anywhere near December 24 without hearing an anchor ask the meteorologist, "Are we getting a white Christmas…?"

DECEMBER 25, 1954

Johnny Ace Dead

Today in 1954, soul singer Johnny Ace died from an accidental, self-inflicted gunshot wound backstage at the City Auditorium. Months after his death, Ace had a number-one R&B song with "Pledging My Love."

DECEMBER 26, 1929

Independence Heights Annexed

In 1905, the Wright Land Company developed an area outside segregated Houston and sold lots to African Americans. The first deeds were recorded in 1908, and the first school opened in 1911. When Independence Heights was incorporated in 1915, the first four hundred residents elected George Burgess as their mayor and worked on providing city services for themselves. Today in 1929, Independence Heights was annexed by the City of Houston.

DECEMBER 27, 2012

Rodeo Bought AstroWorld Site

Today in 2012, the Houston Livestock Show and Rodeo purchased forty-eight acres of empty land out of a ninety-two-acre site commonly referred to as the AstroWorld property for $42.8 million from Fort Worth investors, who themselves acquired the former amusement park land in 2010. The site is south of the Rodeo's home at Reliant Park and includes a pedestrian bridge that crosses over Loop 610. AstroWorld was closed in 2005.

DECEMBER 28, 1859

Congregation Beth Israel Chartered

Today in 1859, the Hebrew Congregation of the City of Houston was chartered, with twenty-two members. The oldest Jewish house of worship in Texas was incorporated as the Hebrew Congregation Beth Israel in 1873. Its Franklin Avenue temple was completed in 1874 and replaced by another synagogue on Holman Avenue in 1925. The Hebrew Congregation Beth Israel changed its name to the current Congregation Beth Israel in 1945 and moved to its present site on South Braeswood in 1967. Beth Israel administers the historic Beth Israel Cemetery on West Dallas.

DECEMBER 29, 1845

Texas Admitted to the United States

On this day in 1845, the United States Congress voted to annex the independent Republic of Texas. When General Sam Houston was elected president of the Republic of Texas in 1836, voters also agreed to seek entry into the Union. The U.S. Congress, divided over admitting new states that would allow slaves, delayed Texas's request for admission. Eventually, Texas entered the United States as a slave state, pushing the Union closer to civil war. Mexico and Texas had not officially settled ownership of the land between the two nations, north of the Rio Grande and south of the Nueces River, but later resolved it following the Mexican-American War in the Treaty of Guadalupe Hidalgo in 1848.

DECEMBER 30, 1905

Carrie Nation's Wrath

Today in 1905, temperance crusader Carrie Nation trashed the ironically named Carrie Nation Saloon on Willow at Wood Street over the misuse of her name. Months earlier, she had warned the owner to remove her name, and when she returned to town, Nation shattered a mirror with a thrown brick and took an axe to a case of whiskey. She caused $750 in damages, but even though she admitted to her actions, the police did not file charges. The bar reopened later as the Carnation Saloon.

DECEMBER 31, 1976

Willie Nelson's New Year's Eve Party

Who doesn't love Willie Nelson? His shows are more party than concert, and his music spans generations of fans. Before he became a bona fide icon, the native Texan lived in Houston for a spell. While not well known, Willie's other big Houston connection is through his signature opening song "Whiskey River," co-written by native Houstonian Johnny Bush. Today in 1976, Willie played the first in a series of annual New Year's Eve shows at the Summit in Houston. He would bring the party to Houston again in 1981, 1982 and 1984, with friends Waylon Jennings, Leon Russell, Kris Kristofferson, B.B. King and Johnny Cash.

INDEX

S

T

U

ABOUT THE AUTHOR

James Glassman is a fifth-generation Houstonian and works as an architectural project manager in Houston. He has a bachelor of arts in history from Kenyon College and a master of architecture from the University of Houston. In 2006, he founded Houstorian, dedicated to telling the story of Houston. In 2013, he was honored by the *Houston Press* as one of its 100 Creatives and by the *Houston Chronicle* as one of 2013's Most Fascinating People. He won Tweet of the Year at the 2013 *Houston Press* Web Awards. He has also been recognized for his advocacy of the Astrodome with quotes in the *New York Times*, the *Guardian*, the *Atlantic Monthly* and the *Houston Chronicle*. His Houston-inspired graphic designs have been featured in *Houstonia Magazine*, the *Houston Chronicle*, the *Houston Press* and CultureMap. In 2015, The History Press published his first book, *The Houstorian Dictionary: An Insider's Index to Houston*, which lists the people, places, things, terms, slang, quotations, events, books, movies and songs that make Houston fun and unique.